How to Get the Best Travel Photographs

Fredrik D. Bodin

Curtin & London, Inc. Somerville Massachusetts

Van Nostrand Reinhold Company New York Cincinnati Toronto Melbourne

Printed in the United States of America

Published in 1982 by Curtin & London, Inc.
and Van Nostrand Reinhold Company
135 West 50th Street, New York, NY 10020, U.S.A.

Van Nostrand Reinhold Limited
1410 Birchmount Road
Scarborough, Ontario M1P 2E7, Canada

Van Nostrand Reinhold Pty. Ltd.
17 Queen Street
Mitcham, Victoria 3132, Australia

Interior design and cover design: Richard Spencer
Illustrations: Glenna Lang
Production editor: Lisbeth Murray
Composition: P & M Typesetting, Inc.
Printing and binding: Halliday Lithograph
Color insert: Phoenix Color
Covers: Phoenix Color
Front cover photograph: Courtesy of Minolta Corp.
Background map on cover: Courtesy of DeLorme
 Publishing Company, Freeport, Maine

All photographs by Fredrik D. Bodin unless otherwise credited.

10 9 8 7 6 5 4 3 2 1

Library of Congress Cataloging in Publication Data

Bodin, Fredrik D., 1950—
 How to get the best travel photographs.

 Includes index.
 1. Travel photography. I. Title.
TR790.B6 1982 778.9'991 82-13969
ISBN 0-930764-40-4

Contents

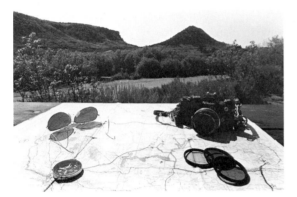
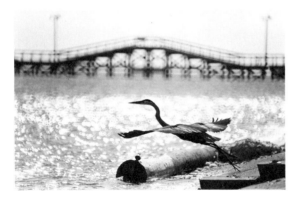
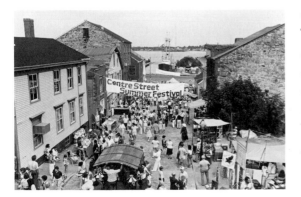

Contents

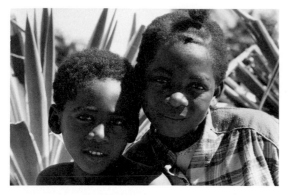

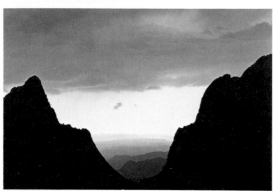

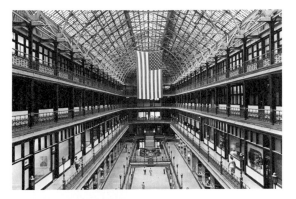

Introduction

Taking pictures is part of the experience of traveling. Most people, regardless of their home port, might forget to pack a toothbrush—but not their camera! Travel photography is a visual remembrance of where you've journeyed, what you looked like there, and the faces of friends found along the way. There is no better souvenir.

Evidence of the well-traveled camera is all around us. Regions seeking your travel dollar advertise with picturesque snapshots—the kind we tourists love to take home. Scenic roadways have been developed with the photographer in mind: there are well marked photo vantage points where you can safely pull off the highway and photograph. If you should run out of film, reinforcements are as near as the gift shop, drug store, or film booth. And, if you can't find a suitable country to point your lens at, photographic workshops and travel companies have itineraries designed for photographers.

The voyager with a camera is a special character in foreign countries. You are there to observe, to learn, and to enjoy. A trip can be a cultural adventure into another people's way of living. Often, local residents find a traveler's curiosity flattering, and will take extra measures to accommodate you.

The wanderer is expected to be lost and seek directions, ask advice on exotic menus, smile helplessly amidst new customs, and gaze in wonder at new cities. The camera is your visitor's badge. The camera links you more directly to the traveling experience. It is difficult, if not impossible, to separate yourself from your pictured subjects. When you snap a picture, your subjects may smile or go about their business. Passersby may puzzle about what the devil you find so interesting. Amateur photographers will stop and engage in camera talk. Many times traveling photographers in Boston or New York City have asked me to photograph them with their own cameras. When you're taking pictures, you've got a recognized license to loiter, fumble, gawk, and chat with perfect strangers.

In many ways, you traveling photographers are special in a sea of tourists. You are more sensitive and aware of the cultural environment, because you're looking for a good picture. Your antennae are up and you're approachable. And you're special because you're creating a personal artistic statement for the fun of it.

Acknowledgments: Thank you, Nancy Dudley, for your support, patience, and contributions to this book. My gratitude to Lisa Faneuf, Alice Zingaro, and Lisbeth Murray for helping put it all together. And deepest appreciation to our two traveling photographers, Ulrike Welsch and Cary Wolinsky, for sharing their pictures and professional insights with us in *How to Get the Best Travel Photographs*.

◄You don't have to go halfway around the world to take travel pictures: a weekend drive, a day trip, or anywhere over your backyard fence, and you're a potential travel photographer. What makes a good travel photo is the way you look at things through the camera.

You can't take it all with you. Some fore-thought and research will help you buy and bring the right equipment. Once you're out there, you'll be glad you did some planning at home.

2

1

Packing and Planning

Cameras

A heavy camera bag is a burden travelers need not bear. Fortunately, there is no correlation between the weight on your shoulder and how good your pictures will be. Always travel as light as you can. Freedom and mobility are the best means to spontaneous and exciting travel photographs.

Professionals and amateurs alike overwhelmingly favor the 35mm camera for travel photography. It is small and lightweight, yet gives a quality image that is suitable for publication. The 35mm camera is also versatile, with an array of lenses, viewfinders, auto winders, and filters available for most brands. The new automatic exposure cameras make picture-taking easy, a fact of particular importance to beginning photographers. And "35s" aren't as expensive as one might think—they start at about $75 for a good rangefinder and an average SLR (single-lens-reflex) goes for about $300.

The type of 35mm camera you buy depends on your budget and what kind of photography you expect to be doing.

Rangefinder 35mm cameras are distinguished by a small window next to the lens, through which framing and focusing are done. Rangefinders are generally inexpensive, lightweight, compact, and unobtrusive. Many rangefinder cameras have an automatic exposure mode, and a few offer interchangeable lenses and other accessories.

A rangefinder is a basic picture-taking machine. It can be a rugged companion on camping trips, canoe outings, or bike hikes. Rangefinders are easy to tote around, quick to focus and shoot, and can take great pictures. The 35mm camera scene was dominated by rangefinders until the 1960's, when the SLR became popular.

▲
Rangefinder 35mm cameras yield quality images, yet are lightweight and relatively inexpensive. A simple rangefinder makes an excellent first camera.

▲
Super compact 110 and 35mm cameras are becoming increasingly popular. Most have a rangefinder format, and some offer interchangeable lenses.

Single-lens-reflex (SLR) cameras allow the photographer to view and focus through the picture-taking lens. This is a particular advantage for close-up photography and precise framing. Like rangefinders, many SLR cameras have automatic exposure, and almost all SLRs offer interchangeable lenses. The accessories available for the SLR are staggering: eyepieces, diopters, filters, winders, viewing screens, microscope and telescope attachments, teleconverters, and more.

An SLR costs more than a rangefinder, but if you intend to get heavily involved in creative photography, take many close-up shots, or anticipate special applications (such as long-lens nature photography), then buy an SLR. Remember that it is the photographer who takes a good picture—not the camera. Choose a 35mm, be it rangefinder or SLR, that meets *your* needs.

Medium-format cameras deserve to be mentioned here. Although heavier than a 35mm camera, a medium-format camera will yield a better quality photograph because of its larger film size. If superlative quality is your aim, and the extra weight doesn't bother you, investigate these cameras.

◄The most versatile and widely used 35mm camera is the single-lens-reflex (SLR). Although heavier and more expensive than rangefinder cameras, SLRs are better suited for close-up and telephoto photography.

▲
Medium-format cameras, also called 2¼ × 2¼ or 2¼ × 2¾ cameras, produce a better quality image than 35mms because the film size is larger. Fine detail, razor sharpness, and vivid colors are apparent in enlarged prints made from medium-format cameras.

Lenses

Using interchangeable lenses gives the photographer the choice of including a wide area in the picture or bringing distant objects in close. Lenses are measured in millimeters according to their focal length (the distance from the optical center of the lens to the film plane when the lens is focused at infinity). With a little practice, you can learn which lens is best suited to the situation at hand.

Normal Lenses: A normal, or 50mm-focal-length lens, comes with most 35mm cameras, unless you specifically purchase the camera body only. A 50mm lens is for general pur-

pose photography. It records a scene with about the same magnification and angle of coverage as your eyes would. An inherent advantage of the normal lens is its speed (the "speed" of a lens refers to the size of its largest aperture, usually f/1.4 or f/2), which makes it good for photographing in low-light situations.

A normal lens can be used effectively in most photographic situations if the photographer is willing to step up close to the subject instead of using a telephoto, or move back to cover a wider area. The versatility of a normal lens can be augmented by using a teleconverter (see page 9). Likewise, adding close-up filters or extension tubes (see pages 74–75) to a normal lens permits photography at greater magnification.

Wide-Angle Lenses: Wide-angles range from 6mm in focal length (fisheye lenses) to 35mm in focal length. Wide-angle lenses are used to cover a tight situation where you can't step back, such as a street bazaar, alleyway, or inside a small room. They are also useful tools for landscape photography (see Chapter 5).

One favorable characteristic of the wide-angle lens is its extreme depth of field (the distance from the nearest to the farthest objects which will be sharp in the photo). When the lens opening (f-stop) is set for f/8 or f/11, a feasible aperture in bright sunlight with a medium-speed film, it is possible to get near and far objects in focus

This landscape was shot ▶ with a 55mm normal lens. It's wise to learn how to take good pictures with the lens you've got before buying others. (Photo by Nancy Dudley)

A dimly lit scene, such ▶ as this indoor livestock exhibit, is handled well by a fast normal lens. (Photo by Nancy Dudley)

CHARLOTTESVILLE, VIRGINIA

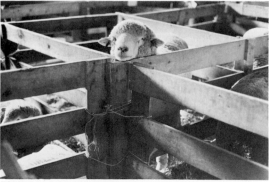

TOPSFIELD, MASSACHUSETTS

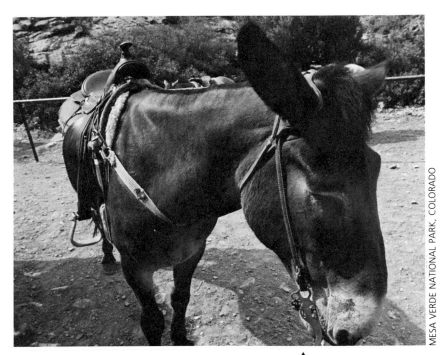

MESA VERDE NATIONAL PARK, COLORADO

at the same time. Such depth of field is difficult to achieve with a normal lens, and nearly impossible with a telephoto.

Distortion can be an unfavorable characteristic of wide-angles. When the lens is pointed upward to include a tall building, the bottom of the building will be closer to the lens than the top, which will make the walls seem to slant in toward the center of the photo. The lens also makes near objects appear overly large in proportion to far objects, which look small. Close-up portraits made with a wide-angle lens are unflattering, to say the least, because the nearest object is your subject's nose!

Distortion can be a graphic tool in the hands of a photographer familiar with wide-angles. The foreground can come to life, fences and railroad tracks can go on forever, and distortion can be humorous. The best way to learn is to put a wide-angle lens on your camera and do some exploring.

▲
Wide-angle lenses make near objects appear large. This kind of distortion made the mule's head large in comparison to the rest of his body.

◄ Here wide-angle distortion is used advantageously. The converging lines of one of the World Trade Towers create a pleasing pattern and suggest the building's height.

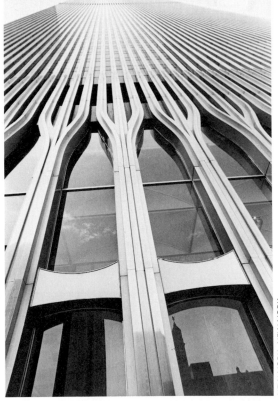

NEW YORK, NEW YORK

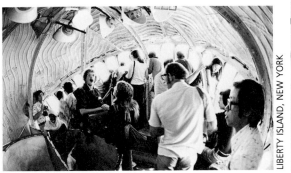

LIBERTY ISLAND, NEW YORK

▲
Photographing inside small spaces like the head of the Statue of Liberty is best done with a wide-angle lens.

(continued) **Lenses**

Telephoto Lenses: Telephotos are available in 85mm through 2000mm focal lengths, and longer. Their basic function is to photograph a small, distant subject as a larger, and seemingly closer, image on the film. A moose across the meadow looks far away when shot with a normal or wide-angle lens. But the moose, his antlers, and the grass he's nibbling on, look close when photographed with a telephoto lens.

Short telephotos, such as the 85mm and 105mm, are excellent portrait lenses. They allow you to shoot at a comfortable distance—say 6–8 feet, which keeps you far enough away to prevent distortion. In addition to being lighter to carry than their longer cousins, short telephotos are faster (have a wider maximum aperture, see page 24), thus allowing you to shoot in naturally lit environments without a tripod. A characteristic common to all telephotos is very shallow depth of field. This is handy in portrait photography, where distracting backgrounds are neutralized by being thrown out of focus.

Long telephotos, the 135mm, 200mm, 300mm and longer, are great for sporting events, wildlife photography, or picking out a character at the zoo. Where there are retaining gates, walls, fences, or a skittish wild beast, the telephoto will permit you to stand relatively far away and still fill the frame.

Aside from its weight and bulk, the telephoto has some other drawbacks. You'll notice, while looking through your telephoto, that the least amount of camera shake really shows up in the viewfinder. Unfortunately, it will also show up in the picture, as a blur. For shutter speeds that are smaller numbers than your lens' focal length in millimeters, use a tripod or cradle the lens on a stationary object (1/250 sec. is fast enough for a 135mm lens, but not for a 500mm lens). City haze or smog is also a problem with long lenses when you are shooting scenes at a great distance. The more haze you shoot through, the grayer your photos will be. Filters can help (see page 40), but getting closer is the best solution.

Telephotos create a graphic effect called compression. Compression makes near and far objects seem close together. A telephoto aimed down a long row of houses will make them look very close together, even when they're not. Try using the telephoto's compression effect for pictures with impact: traffic, the palace guard on review, rowhouses, cemeteries, or the start of a race.

Telephoto compression ▶ visually brought the Manhattan high-rise and the snarled traffic together. Use a telephoto's "crowding effect" to make any two objects appear closer together in a photograph. (EPA–Documerica Photo by Dan McCoy)

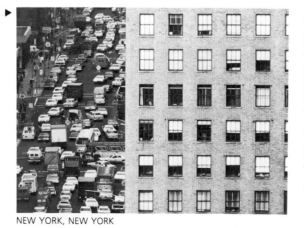

NEW YORK, NEW YORK

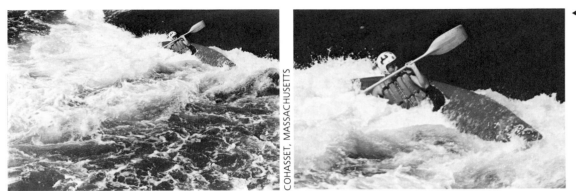

COHASSET, MASSACHUSETTS

◀Zoom lenses are especially useful when the subject is in action. In a matter of seconds, a zoom can be extended to bring the image closer for more graphic framing.

Zoom Lenses: Much can be said for the advantages of using a zoom lens in travel photography. A zoom is a variable-focal-length lens. An 80-200mm zoom, for example, can be used as an 80mm lens, and by sliding the zoom ring forward, it can be lengthened to every focal length up to, and including, 200mm. One zoom can save considerable weight when substituted for two or three conventional lenses.

There is another plus for zooms. The unexpected is a constant when you are traveling. A good picture opportunity may present itself around the next corner, but you may not have time to change lenses or position yourself. With a zoom you can control the image size precisely, and in seconds. And as the focal length of a zoom changes—so do your perspective controls of depth of field and compression.

Teleconverters: Teleconverters also extend the versatility of your lens arsenal. They fit behind the lens and can double (called a 2X) or triple (3X) the focal length of your lens. Small and lightweight, a 2X teleconverter fitted to a 200mm lens results in a long 400mm telephoto.

Teleconverters and zooms do have a few disadvantages. Both undeniably cannot match the speed (widest possible lens aperture) of conventional lenses, which could inhibit shooting in available light situations when light levels are low. And there is much controversy about teleconverters and zooms causing a loss of contrast, sharpness, and color shift. If you are considering purchasing either a zoom lens or a teleconverter, look for quality products.

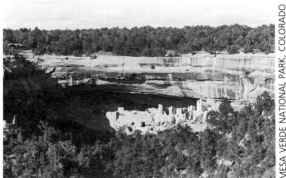

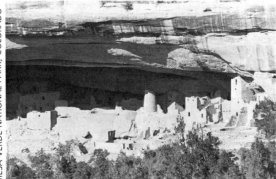

MESA VERDE NATIONAL PARK, COLORADO

◀When you can't get closer to a distant subject, a teleconverter will double or triple the focal length of your lens. In this case, it made the cliff dwelling more prominent by eliminating unwanted trees and shadow.

Accessories

Electronic Flash: For situations where there's just not enough existing light for pictures, an automatic flash unit will be necessary. Some models are hardly larger than a pack of cigarettes. Once set on automatic for the film speed you're using, the flash will take properly exposed photos at any distance up to the maximum distance given for the particular unit. Look for a flash that will operate on rechargeable batteries to save money and time hunting around for new batteries. Consult your photo dealer for a battery charger compatible with electric systems in other countries.

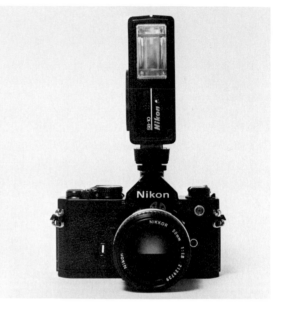

Lens Cleaning Kit: The kit consists of a small soft brush, lens cleaning tissue, and lens cleaning solution in a small plastic bottle. Cleaning a lens is easy: 1) Lightly brush off dirt, dust, and grit; 2) With a drop of solution applied to a wadded-up piece of lens cleaning tissue, gently wipe lens surface with circular motion; 3) Dry lens surface with second piece of wadded lens tissue; 4) Brush remaining lint from lens surface. Remember to clean both sides of the lens, when necessary.

1

2

3

4

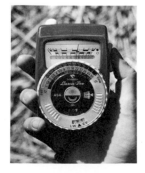

Light Meter: Even if your camera has a built-in meter, there may be times when using a small hand-held meter will give more accurate exposure readings (see Chapter 2 on exposure).

Tripod: For sunset, night, or indoor pictures without a flash, pack a compact tabletop tripod and cable release.

Filters

Filter	Film	Uses	Without filter	With filter
Skylight (1A) Ultraviolet (UV)	Color and black-and-white	Reduces haze and blue cast, especially in shade. Protects front lens element from dust, spray, and abrasion.		
Polarizer	Color and black-and-white	Darkens sky, increases contrast and color saturation. Reduces reflections and substantially cuts haze.		
Deep yellow (#15)	Black-and-white	Noticeably darkens blue sky and makes clouds stand out. Reduces bluish haze. Medium yellow (#8) filter has somewhat less effect.		
Medium red (#25)	Black-and-white	Dramatically darkens blue sky. Cuts haze.		
Yellow green (#11)	Black-and-white	Lightens foliage, improves detail in leafy plants, and helps outdoor portraits.		

Special effects filters are covered in Chapter 6.

Camera Bags

No perfect camera bag exists for all photographers and all circumstances. Its size will be determined by how much equipment you want to carry, how far you'll be hoofing it, and how strenuous your activity will be. Perhaps bringing two camera bags, a large one and a small one, will cover most situations.

Fanny Pack Bag. ▶
Holds one camera and one lens, or three lenses if camera is hung around neck. Limited room for a small light meter and six rolls of unboxed film. Look for waist strap, hooks for shoulder strap, and a sturdy zipper. Fully loaded weight approximately 4 pounds. Dimensions about 12"L × 5"H × 6"W, will fold into corner of suitcase. Costs $18.00. (You can make your own photo fanny pack from those sold by outdoor sports stores and a block of foam. Costs $10.)

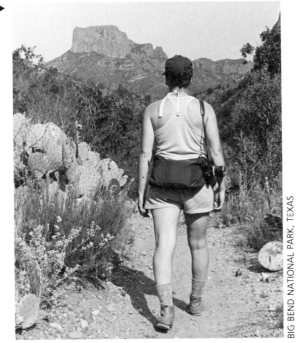

BIG BEND NATIONAL PARK, TEXAS

AZTEC RUINS, NEW MEXICO

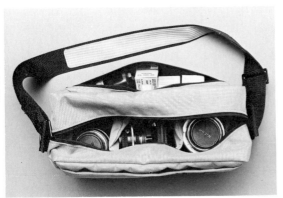

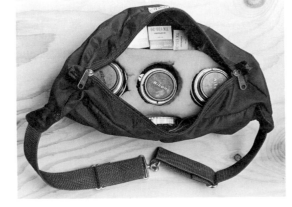

▲
Small Padded Camera Bag. Holds one camera body and two lenses, a small light meter, filters, six rolls of film, and documents. Look for sturdy zippers and stitching, convenience of access, and enough room for your particular camera system. Fully loaded weight approximately 7 pounds. Dimensions about 12"L × 6"W × 8"H. Costs $20 to $50.

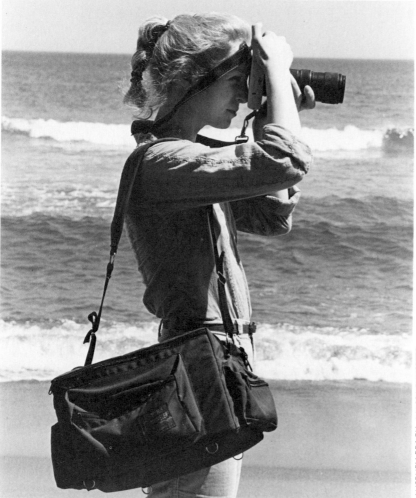

SALISBURY BEACH, MASSACHUSETTS

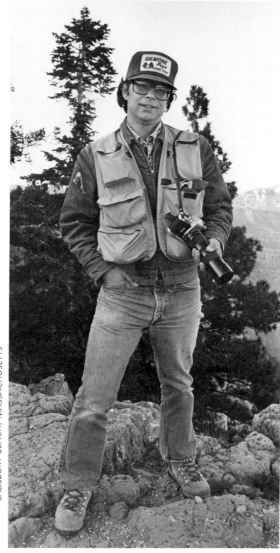

GRAND CANYON NATIONAL PARK, ARIZONA

▲
Large Padded Camera Bag. Holds two camera bodies with lenses, three extra lenses, light meter, filters, twelve rolls of film, and documents. Look for padded shoulder strap, waist strap, and tripod straps. Fully loaded weight approximately 12 pounds. Dimensions approximately 16"L × 12"W × 10"H, will fit under large aircraft seat. Costs $50 to $150.

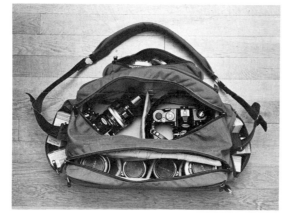

▲
Safari Jacket or Camera Vest. Actually any jacket with two or more large pockets will suffice. Holds small camera and lens or two short lenses if camera is worn around neck.

There should be room for a few rolls of film, but not much more in the chest pockets. The loaded weight of 6 pounds is comfortably distributed. Costs $25 to $100.

Black-and-White Films

Film Choice

Bring plenty of your favorite kind of film with you. Buying film abroad may be more expensive and may be of a different quality. It is unwise to shoot all of your travel pictures on a film you're unfamiliar with. If you must try something new, shoot and examine a few rolls before leaving.

The film chosen for a trip should satisfy two criteria. It must produce a result to meet your needs (black-and-white or color, slides or prints). Your film should also fit the lighting conditions you expect to use it under (sunlight, indoors, underwater, etc.). Often, more than one type of film will be needed to meet the needs of varied situations.

Black-and-White Films

Black-and-white films are developed into negatives, which are used to make black-and-white prints. Although black-and-white film is less costly than color, having every frame printed is still expensive. An alternative is to have a contact sheet made. A contact sheet is a printing of the entire roll on an 8 × 10 inch sheet of photographic paper (each frame is the same size as the negative). The contact sheet can be examined with a magnifying glass and the best pictures chosen for enlargement.

A photo lab can develop and print black-and-white pictures, or you can do it yourself at home. Many photographers delight in the magic of processing their own pictures. It is not as difficult as one might think, and can be performed in the bathroom or kitchen at night. Processing can be self-taught in a matter of hours with the help of a good reference book (*Into Your Darkroom Step by Step,* by Dennis Curtin. Somerville, MA: Curtin & London, Inc., 1981).

The big difference among black-and-white films is their film speed and corresponding image quality. Films with higher ASA/ISO numbers are called fast films. Kodak Tri-X and Ilford HP4 are fast films (ASA/ISO 400) and are best suited for photographing action, indoor scenes, and available light situations. Fast films are the best general purpose films because they can be used under almost all conditions. However, these films result in grainier photos than do their lower ASA/ISO film speed cousins.

Slow- and medium-speed films have low ASA/ISO numbers. Landscapes, still lifes, and architecture reveal fine detail and wide tonal range when photographed with films such as Kodak's Panatomic-X (ASA/ISO 32). Large-sized prints of excellent quality can be made from slow- and medium-speed films. When it comes to freezing action in a picture, though, slow films don't perform well.

Black-and-White Film Use Chart

Film	ASA/ISO	Grain	Uses
Agfapan 25	25	Very fine	Still lifes, landscapes, portraits, nature.
Ilford Pan F	50		
Kodak Panatomic-X	32		
Agfapan 100	100	Fine	Landscapes, portraits, daytime action, nature, close-ups, general.
Ilford FP4	125		
Kodak Plus-X Pan	125		
Agfapan 400	400	Medium	Fast action, mixed inside and outside scenes, most existing light scenes.
Ilford HP5 & XP1 400	400		
Kodak Tri-X Pan	400		
Kodak Recording Film	1000	Coarse	Dim available light, night street scenes.
Kodak Royal-X Pan	1250		

CAUTION:
Always buy fresh film. The expiration date of film is stamped on the side of the box. Heat deteriorates film rapidly, so store your unexposed film in a refrigerator. Allow film to thaw ½ hour before using. Never leave film in a closed hot car. Process exposed film as soon as possible.

▲
Black-and-white negative.

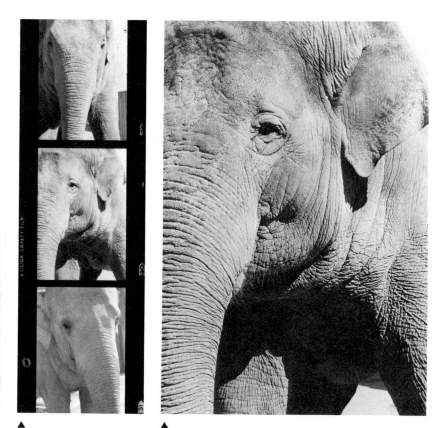

▲
Contact sheet from black-and-white negatives.

▲
Print from black-and-white negative.

Color Films

There are basically two types of color film: color negative film and color slide (positive) film. Color negative film is designed so the end result will be a color print. You can have small 3 × 5 inch prints made relatively inexpensively ($13–$16 for 36 exposures), or you can look into color contact sheets. The greatest advantage of shooting color negative film is the superior quality of large prints. That's why wedding photographers shoot color negatives: the desired results are prints to put in an album or hang on the wall. All color negative film names end with the word "color" (for example, Kodacolor).

Color slide film is made to be shown in a slide projector. Processing color slides for projection costs about one-third of what having a roll of color negative film printed costs. Any size print can then be made from a color slide, although it may be slightly more expensive than a print made from a color negative. The color print quality from slides and negatives is about the same. Color negative film will allow the photographer to err more in the exposure (latitude) and still get an acceptable print. Color slide films end with the suffix "chrome" (for example, Agfachrome).

Professional photographers who shoot for magazines and other publications shoot only color slide film. The reason: the printing and publishing industry is set up to make color reproductions from slides. So if you intend to sell your travel photos one day (see Chapter 8), shoot slide film.

Like black-and-white films, color films are available with high ASA/ISO numbers (like Ektachrome 400) for action and available light photography. Color films also come in slower ASA/ISO speeds for brightly lit subjects (Kodachrome 25). And like black-and-white films, the quality of the color image goes down when the film speed goes up. For example, the color rendition, sharpness, and grain structure will look better in a print made from Kodacolor 64 than from Kodacolor 400.

Although your eye doesn't notice it, light coming from light bulbs is much more yellow than light from the sun. Indoor color film takes this into account and gives fairly accurate color rendition indoors. Such films are labeled "tungsten," "Type A," or "Type B." When indoor color film is used in sunlight, a blue picture will result, unless an 85B filter is used. Use "daylight" color film when the light source is the sun or an electronic flash. If you try shooting daylight film indoors, expect a yellow picture, unless you use an 80B filter.

Color Film Use Chart

Film	ASA/ISO	Color balance	Uses
Kodachrome 25	25	Daylight	Still lifes, landscapes.
Kodachrome 64	64	Daylight	Still lifes, landscapes, daytime action, outdoor portraits, nature, sunsets.
Ektachrome 64	64	Daylight	
Agfachrome 64	64	Daylight	
Agfachrome 100	100	Daylight	Landscapes, daytime action, outdoor portraits, nature close-ups, late afternoon scenes.
Fujichrome 100	100	Daylight	
Fujicolor F-11	100	Daylight	
Kodacolor II	100	Daylight	
Ektachrome 200	200	Daylight	Fast action, heavy overcast sky, deep forest, underwater 20 feet and below.
Ektachrome 400	400	Daylight	
Fujicolor 400	400	Daylight	
Kodacolor 400	400	Daylight	
Kodachrome II	40	Tungsten: 3400 K	Interior still lifes, studio light setups.
Ektachrome 50	50	Tungsten: 3200 K	
Ektachrome 160	160	Tungsten: 3200 K	Interior existing artificial light.
3M 640T	640	Tungsten: 3200 K	

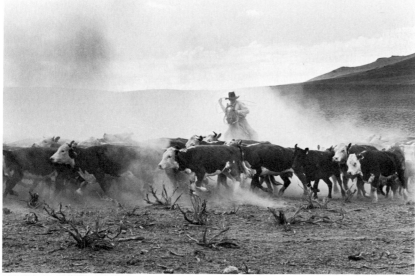

HUMBOLDT COUNTY, NEVADA

◀ Morning and evening light are the most colorful, but not very bright. A high-speed color film will allow you to photograph action early or late in the day and still freeze the motion. (American Folklife Center Photo by Carl Fleischhauer)

Before You Go

Researching a Trip

Knowing a bit about your destination can stack the odds in your favor for better pictures. Will it be cloudy a lot of the time? Will the sun be blazing hot, or will industrial haze be a problem? It's not hard to anticipate shooting conditions if you do some research.

Places of visual richness are easy to locate before you get there. Peruse relevant picture books at the library or bookstore. In minutes, a book will reveal locations, ideas, and photo insights that may have taken a professional travel photographer years to find.

Write to the appropriate chamber of commerce, department of tourism, or embassy for free information. Travel agencies are glad to distribute information packets and tour brochures.

On arrival, investigate sources of tourist information at your destination. Bookstores, postcards, and souvenir slides may help you get oriented. One strong image you see on a poster might save a day's driving to find a dramatic shot.

Sources for Travel Research

- *National Geographic* magazine
- *GEO* magazine
- *Signature* magazine
- *Travel and Leisure* magazine
- Airline in-flight magazines
- Picture books
- Regional tourist information offices
- Television travel programs
- Travel books and guides

◄ The preparation done prior to traveling can save time and money. Film costs more in tourist areas, batteries and accessories may be difficult to find, and you want to be sure that everything is functioning properly before leaving. Once you take off, it may be too late.

TRURO, MASSACHUSETTS

Travel Photographer's Checklist

☐ Necessary ■ Optional

☐ Camera with sturdy strap

☐ 50mm or 55mm normal lens

☐ 24mm to 35mm wide-angle lens

☐ 85mm to 500mm telephoto lens

 Zoom lens

 Close-up attachments

 Teleconverter

☐ Filters

☐ Lens cleaning brush, tissue, fluid

 Hand-held light meter

☐ Fresh batteries

☐ Film: black-and-white and/or color

 Electronic flash

 Tripod

 Cable release

 Instant camera with film

☐ Camera bag

NOTE:
Be sure your equipment is functioning before you travel. Shoot a roll of the film you'll be using *before* leaving. Any serious problems should show up on the processed film. The worst surprise after a trip is finding out about a camera malfunction.

▲
Photographers need protection against the elements too. These shooting mits allow your fingers access to the camera controls without removing the gloves. The Velcro flaps can be sealed when you're not shooting.

(continued) # Before You Go

Insurance

Whether your camera is with you on a trip or left at home, you'll breathe easier knowing that it's insured. Homeowners' and renters' policies have set limits on camera coverage. Examine your policy with your insurance agent to determine if extra coverage is needed. Buying a camera "floater" for your present policy will extend your coverage.

Professional photographers must buy a professional camera insurance policy, which costs about $25 per $1000 of insured equipment. Professional policies cover any kind of loss, except normal wear and tear.

Should a loss of equipment occur on a trip, you'll need a description and serial numbers for the police report and insurance claim. Make two photocopies of the itemized equipment inventory on your insurance policy. Or make your own inventory below and make two photocopies of it. Keep one copy at home, lock one copy in a safe deposit box, and carry one copy with you (not in your camera bag).

Travel Equipment Inventory

Insurance Co. _____

Phone _____ Policy # _____ _____

Quantity	Item	Serial #	Value

Take Your Own Passport Photo

It's easy to take your own passport photo with a 35mm camera. Use black-and-white or color negative film. Every country has its own requirements for passport and visa photos. In the United States, follow the instructions below. Then take the appropriate negative and the size requirements (this page) to a custom photo lab for two prints.

U.S. Passport Rules (from form DSP-11 7-79)

1. Two identical prints (from the same negative), recent and portraying a good likeness of the passport bearer, must be supplied. Wear normal street attire, without a hat. Do not wear dark glasses unless required for medical reasons.

2. Photos must be clear, front view, full face, with a light, plain background. Prints must be capable of withstanding 225° Fahrenheit (107° Celsius) for 30 seconds. Most vending machine, instant black-and-white, and Polaroid SX-70 prints will not withstand the mounting temperature.

3. Photographs must be 2 × 2 inches in size. The image size measured from the bottom of the chin to the top of the head (including hair) must not be less than 1 inch nor more than 1⅜ inches.

4. Retouching to eliminate shadows and lines is acceptable. Retouching to the point of changing the applicant's appearance is unacceptable.

5. Photographs must be signed in the center on the reverse.

Position your subject in front of a plain background, such as a light wall or sheet on a clothesline. Frame the photo for a horizontal view covering the head and shoulders (see illustration). Shoot at least ten frames to insure a good expression.

Customs

It's up to the traveler to prove that his or her cameras were not purchased abroad and therefore subject to import duty. Reentry with a small amount of used equipment is seldom a problem, but a suspicious customs officer can impound it. You'll then have to go home and substantiate ownership or else just pay the duty (cameras: 6.9%, lenses: 11.6% in the United States).

A much safer procedure is to register your traveling photo gear with customs at the port of departure. In the United States, this is done on customs Form 4457, "Certificate of Registration for Personal Effects Taken Abroad." A stamped copy of this form will facilitate a smooth reentry into the United States, and can be used for future trips.

▲
You can use your 35mm camera to take passport and international driver's license photos. Be sure to follow your government's specific photo requirements.

Sometimes picture opportunities are gone all too quickly. To minimize the chances of losing a good picture when it is staring you in the face, become familiar with your camera and its operation. The great blue heron gave me only one chance to get this shot.

2

Travel Techniques

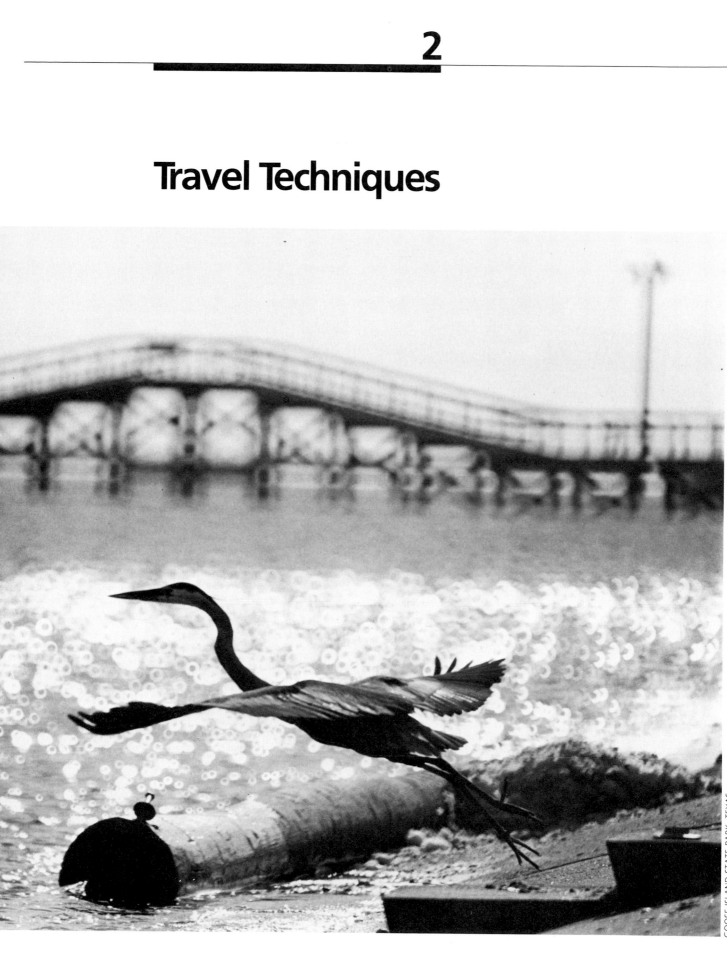

Exposure

Exposure is the amount of light that is allowed to strike the film. You control exposure by setting two camera functions, aperture and shutter speed.

Aperture is the size of the opening in the lens through which light passes. The various apertures are denoted by "f-numbers," or "f-stops." The number f/8 means that the aperture ring on the lens is set at 8. Smaller aperture numbers let in more light than larger numbers; for example, f/2 lets in more light (bigger hole) than f/11 (smaller hole).

Shutter speeds control how long the camera's shutter is open. The numbers on your shutter speed dial (1, 2, 4, 8 through 1000) represent fractions of a second (1 sec., 1/2 sec., 1/4 sec., 1/8 sec. through 1/1000 sec.). The longer the shutter is open, the more the light exposes the film. A 1/2 sec. exposure lets in more light than 1/1000 sec. because the shutter is open longer.

▲ A correct exposure is achieved when the right combination of aperture and shutter speed is used for the light level of a scene. Whether you are using a hand-held light meter or an automatic camera, you must first set the film speed (ASA/ISO number) on the film speed dial. This lets your light meter know how fast or slow your film is, and allows it to gauge film speed against the light level.

▲ Frame the scene you're going to photograph. If the scene is not dominated by very dark or very light colored subject matter, your light meter or automatic camera will give a good exposure. If there are large dark or light subject areas, you may have to compensate to get a proper exposure.

A portrait with a bright ▶ sky background can throw off the exposure. An incorrect exposure was indicated by the light meter because of the bright sky, and a dark portrait resulted.

◀ To compensate for bright backgrounds: 1) Lock in a close-up light reading from a middle-tone object in the scene; or 2) Let in more light by slowing down the shutter speed and/or opening up the lens opening; or 3) Set your exposure compensation dial on +1 or +2.

Exposure Compensation Chart

Subject	Exposure error caused by:	Exposure compensation	Without compensation	With compensation
Beach or snow	Light sand or snow	+ 2 f-stops		
Portrait, close-up	Light background	+ 1 f-stop		
Gray cat	None	0		
Portrait, close-up	Dark skin	− 1 f-stop		
Black cat	Dark fur	− 2 f-stops		

Creative Exposure Control

When you set the exposure, your light meter or automatic exposure system offers a choice of f-stop and shutter speed combinations. The characteristics of particular f-stops and shutter speeds can be used to graphically enhance a photograph.

The f-stop determines how much light passes through a lens. It also controls depth of field—how much of the picture appears sharp from foreground to background. Small lens openings (f/11 or f/16) yield great depth of field. Large lens openings (f/1.4 or f/2) cause shallow depth of field. You can easily investigate your lens depth of field at any given f-stop by looking at the depth-of-field scale on the lens barrel.

Shutter speeds control how long light strikes the film. The shutter speed you select either "freezes" the action, or lets the movement "blur." Your camera angle, the direction of subject motion, and how fast the subject is moving, dictate which shutter speeds are required. A subject moving toward or away from you won't require as fast a shutter speed as a subject moving from right to left. Panning, moving your camera with the motion while taking the picture, will make the subject sharp while blurring the background.

Shallow depth of field can throw a distracting background out of focus. Emphasis can be added by allowing only the most important element of the photo to be in focus. Use a large f-stop (f/1.4 or f/2) for portraits, animal pictures at the zoo, or to single out a subject.

▼

NEW YORK, NEW YORK

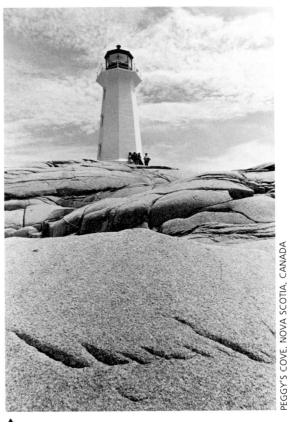

PEGGY'S COVE, NOVA SCOTIA, CANADA

▲
A small f-stop (f/16) was used for obtaining maximum depth of field. The glacial scratches in the foreground and the lighthouse in the background are both in focus. Cityscapes, landscapes, close-ups, and architecture usually require a lot of depth of field.

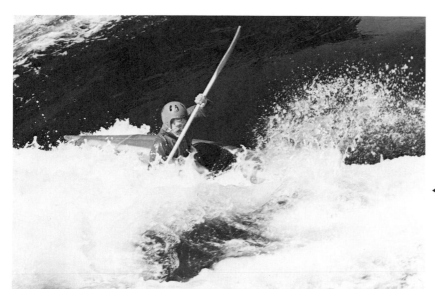

COHASSET, MASSACHUSETTS

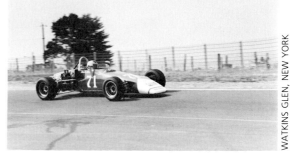

WATKINS GLEN, NEW YORK

◄ The movement of kyack and spray in the rapids was frozen with a shutter speed of 1/500 sec.

▲ The speed and direction of the motion of the race car required a shutter speed of 1/1000 sec. and panning of the camera. Notice how the background became blurred as a result of panning.

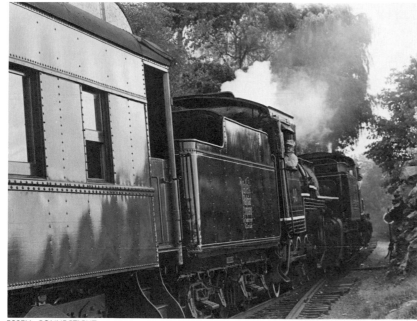

ESSEX, CONNECTICUT

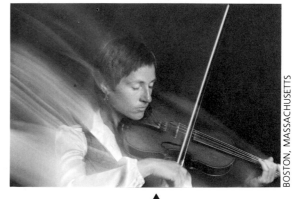

BOSTON, MASSACHUSETTS

◄ Because the train was moving towards the camera, a very fast shutter speed was not required to obtain a sharp image.

▲ A slow shutter speed can be used creatively to imply motion. A speed of 1/15, 1/8, 1/4 sec., or slower, will blur most action. If you want stationary objects to be sharp at these shutter speeds, use a tripod or electronic flash.

Framing

When you look through the view-finder, imagine you're looking at the final picture. Move things around in the picture until they're to your liking. Like moving furniture, change the camera angle, arrange the subject, tidy up the background. The work you do before pressing the button is much more important than what happens after.

Get close. Many pictures fail simply because the photographer was too far away from the subject. Get twice as close to the subject as you think you should be. You paid for the whole piece of film, so you might as well fill it with the subject. A close-up of my little friend's face gave this picture impact. ▶

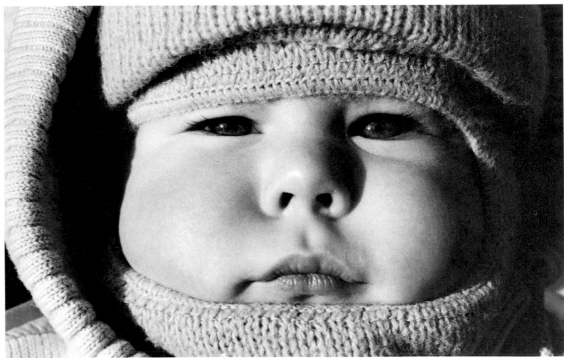

HINGHAM, MASSACHUSETTS

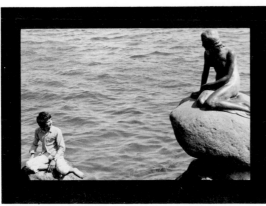

COPENHAGEN, DENMARK

◀ Copenhagen's mermaid and her understudy were framed effectively on opposite sides of the frame. With practice, different subjects will suggest their own rules of framing to you.

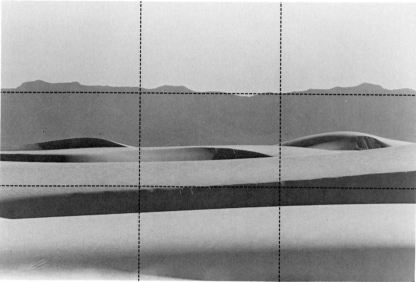

WHITE SANDS NATIONAL MONUMENT, NEW MEXICO

◄Don't always center.
Always placing the subject dead center is an unconscious bad habit. A centered horizon line places emphasis on neither land nor sky. It creates tension. Use the "Rule of Thirds" to find alternatives to centering. Place the main subject in line with one of the "Rule of Thirds" lines or intersections, as in this photo. It works!

DÜSSELDORF, WEST GERMANY

CONCORD, MASSACHUSETTS

◄Interesting angles.
Pictures always taken at eye level can be tedious. Climb up high for a bird's eye view. Get down low to make your subject look big. Look for natural frames and colorful objects to shoot through.

▲ Simplify. Distracting backgrounds, irrelevant objects, and clutter can ruin your pictures. Use your camera to make one clear statement at a time. A simple, direct photo is much stronger than a jumbled one. I liked this particular gravestone, so I moved in close and deliberately left the others out of focus.

Airplane Travel

Flight Packing

Carry on board all of your valuable photo equipment and all of your film. Baggage can be lost, damaged, pilfered, or left in the hot sun. Baggage is also subject to random high-dose X-ray inspection, which can ruin your film.

Carry-on luggage must be compact enough to fit under the airplane seat; 8 × 16 × 21 inches is the maximum size allowed on most large jet aircrafts (or else no more than a total of 45 inches when length, width, and height are added together). Smaller domestic carriers further limit the size of carry-on luggage and may also have weight restrictions. Inquire first, if you don't want your camera bag in the cargo hold!

When you enter the airport departure area, you'll be asked to put your camera bag through an X-ray inspection machine. DO NOT LET YOUR FILM BE X-RAYED! In spite of government denials, there is a good possibility that your film will be fogged by an airport X-ray inspection machine. Don't take that risk with your travel pictures.

Hand inspection is an easy alternative to X-rays. If you make hand examination of your film easy for the inspectors, they'll make it easy for you. Pack your film in a clear plastic bag and put it on top of your cameras in the camera bag. When the moment of inspection comes, pull out the film, let your camera bag go through the X-ray machine, and ask for a hand inspection of your film. It is usually granted.

Small quantities of film can be protected from low-dose X-ray damage with lead foil bags. The added cost and weight of lead film bags may be worthwhile in countries reluctant to hand inspect film.

Airport Photography

I see more interesting faces at an airport than I do anywhere else. Airports have an air of excitement about them and plenty of opportunities for picture-taking. Try to capture the momentum of passengers as they race through the lobbies with one too many suitcase. Look for the weary traveler and the ones whose fate is determined by the arrival and departure screen.

Airport terminal windows offer close-up views of aircrafts being refueled, provisioned, and boarded. Find a clean section of glass and put your lens up against it to eliminate reflections from the inside. If your waiting time will afford it, find out if any tours of the airport are being offered.

Open outdoor observation decks are the most fun at an airport. Here you can shoot the landing and the takeoff. Look for dramatic backgrounds, like tall city buildings or a setting sun. A telephoto or zoom lens will let you fill the frame with an aircraft, and make it look more massive than it really is.

▲
This is the most efficient way to present your film for hand inspection at airports.

Pictures from Aircraft

You can put your carry-on camera gear to use by taking inflight aerial photos. Ask for a window seat forward of the wing. And try to get on the side of the plane that will face the ground when the plane banks after takeoff. You'll have an unobstructed view of the ground. The other side of the plane will face the sky.

You can minimize reflections from inside the aircraft by placing the lens close to the window. And use a fast shutter speed (at least 1/500 sec.) to eliminate the effects of vibration. A polarizing filter, although good for reducing haze, will probably show the blotchy stress marks in the Plexiglas windows. Use a UV filter instead.

When the aircraft has reached cruising altitude and the passengers are allowed to stretch their legs, scout around for larger and better located windows. They may be located near the aft or mid-door areas, or by the kitchen. And if you're lucky, the captain may invite you into the cockpit for some breathtaking photography!

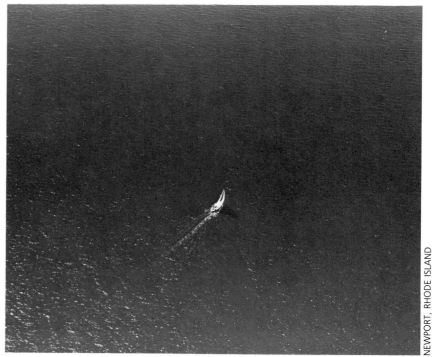

NEWPORT, RHODE ISLAND

▲
Land masses and other familiar ground objects look very different from the air. Here, a sailboat cuts peacefully across the Atlantic.

LA GUARDIA AIRPORT, NEW YORK

Find the observation deck and watch for runway activity. A telephoto or zoom lens will probably be necessary to frame takeoffs and landings. ▶

Automobile Travel

Touring by automobile permits great freedom and flexibility for travel photography. You can stop anywhere, explore areas off the beaten track, make your own schedule, and bring as much extra equipment as you like. Many times I have helplessly watched beautiful picture opportunities go by through a train window. Car travel may be more expensive than public transportation, but it gives you control.

Plan your drive along scenic routes. Motor touring clubs, such as the American Automobile Association, supply maps with marked scenic drives and will even plot the course for you. Touring clubs also supply discount car rentals, coupons for attractions, updated maps, campground and motel directories, and emergency repair service.

Car camping can help offset auto expenses. Reservations are usually not necessary, and overcrowding occurs only at the most popular campgrounds. Many campgrounds have laundry facilities, recreation rooms, playgrounds, pools, and other outdoor recreation. Find a campground near a scenic waterway, park, or forest and you'll be in a prime location for nature photography. It may be worthwhile to make reservations at these campgrounds.

Be careful not to leave film in a hot car. The summer sun will turn a closed-up car into an oven and this will damage your film. Park in the shade or carry all film (exposed and unexposed) with you. When I camp, I keep my film in an ice chest with my perishable food.

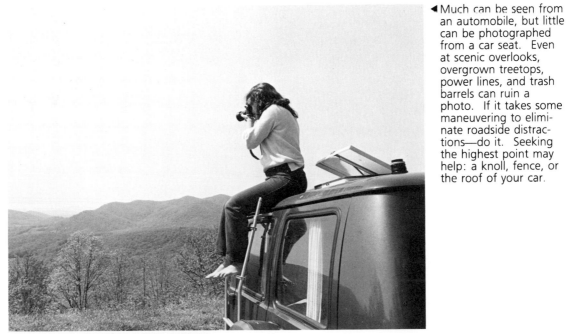

◄ Much can be seen from an automobile, but little can be photographed from a car seat. Even at scenic overlooks, overgrown treetops, power lines, and trash barrels can ruin a photo. If it takes some maneuvering to eliminate roadside distractions—do it. Seeking the highest point may help: a knoll, fence, or the roof of your car.

GREAT SMOKEY MOUNTAINS, NORTH CAROLINA

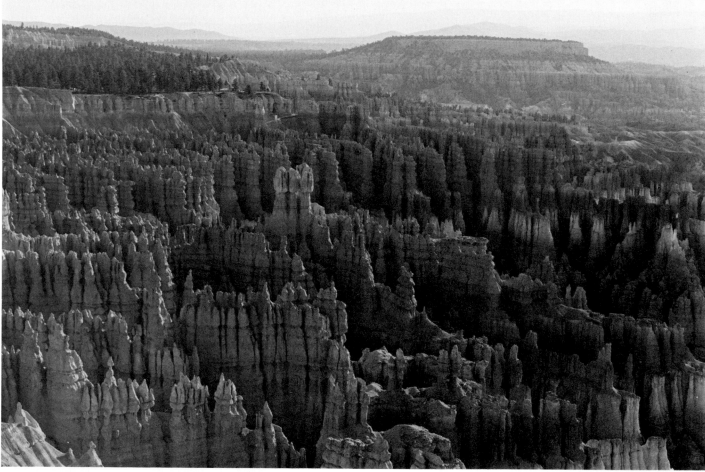

BRYCE CANYON, UTAH

◄ Food and film make good traveling companions. Both need protection from the hot sun and should be kept in a cooler. Put your film in a plastic bag to keep it dry.

▲ Unspoiled landscapes are what many of us travel to see and photograph. It makes sense to bring back clean looking pictures without roadside distractions.

Backpacking

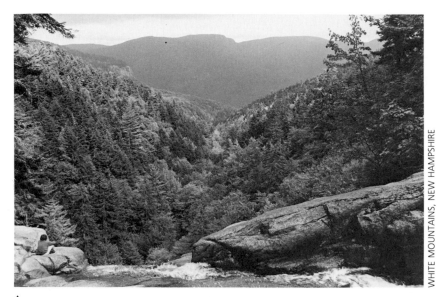

WHITE MOUNTAINS, NEW HAMPSHIRE

▲
There's a jungle out
there, and many good
photos are found off
the beaten track. Much
of the challenge of this
kind of travel photogra-
phy is in getting there.

after your survival gear has been
packed can photo equipment be
added—and only to a reasonable car-
rying weight. You'll soon forget
about photography if you're over-
loaded, cold, or hungry. The best
packs for overnighting are sturdy,
metal-frame backpacks. Photo equip-
ment can be fitted in with clothing.

Backpacking any distance requires
physical conditioning and experience.
It can be very dangerous. Have a
good trail map and never hike alone.
Leave word where you'll be hiking and
your anticipated date of return.

There is no better way of concentrat-
ing on nature photography than by
leaving civilization behind and striking
out on your own. So much beautiful,
unspoiled country is accessible only by
trail that serious consideration must be
given to day hikes and packing in for
overnight camping.

Single-shoulder conventional camera
bags are out of the question for hik-
ing, even on easy terrain. Ordinary
day packs spare the hiker and easily
accommodate camera, lenses, film,
food, and a light jacket. Keep the
camera and lenses in their cases or
wrapped in heavy socks. Special back-
packs are made for carrying photo
equipment, with some extra room for
clothes and supplies. Ultimate Experi-
ence, of Santa Barbara, California,
manufactures photographers' packs.

When camping overnight on a back-
packing trip, precedence must be
given to camping equipment. Only

BRYCE CANYON NATIONAL PARK, UTAH

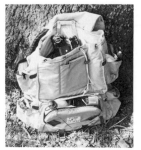

▲
Photo backpacks make
hiking with a complete
camera outfit possible.
This is the Windingo,
made by Ultimate Expe-
rience. The only draw-
back to these packs is
accessibility: the pack
must be taken off to
get at the equipment.
(Photo by Nancy Dudley)

Bicycling

Wheeling around on a bicycle is a peaceful way to see a small town and explore country byways. You can smell bacon cooking in the morning and see the wildflowers growing along the roadside. Picture possibilities slowly unfold as you coast along, and it's easy to stop and take a picture.

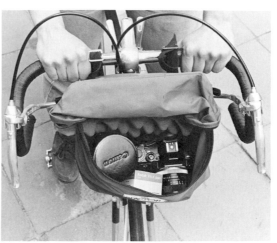

◄A camera and one or two lenses can be conveniently carried in a front handlebar bag. Line the inside of the bag with foam rubber for protection against bumps. When you stop, you'll have access to the equipment without having to dismount the bike.

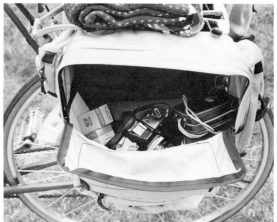

◄For extensive camera equipment or for a combination of camera and camping gear, rear saddlebags are necessary. The cameras and lenses should be kept in foam-lined compartments. As in backpacking, don't overload yourself. If you're using a kickstand, be careful not to let your bicycle blow over in wind. Such episodes lead to the camera repair shop.

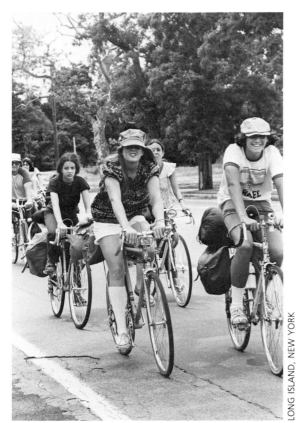

LONG ISLAND, NEW YORK

▲
Bicycle touring organizations take groups along the safest and most scenic routes, and will make arrangements for food and accommodations. Bicycling magazines are a good source of itinerary ideas, whether you're pedaling for an afternoon or a month.

Cities are a rich source ▶
for pictures. A region
or culture will reflect its
character most dramati-
cally in a city or town.
And because urban
areas are the crossroads
of transportation, enter-
tainment, and services,
even wilderness bound
travelers enjoy picture-
taking while passing
through the city.

3

The City

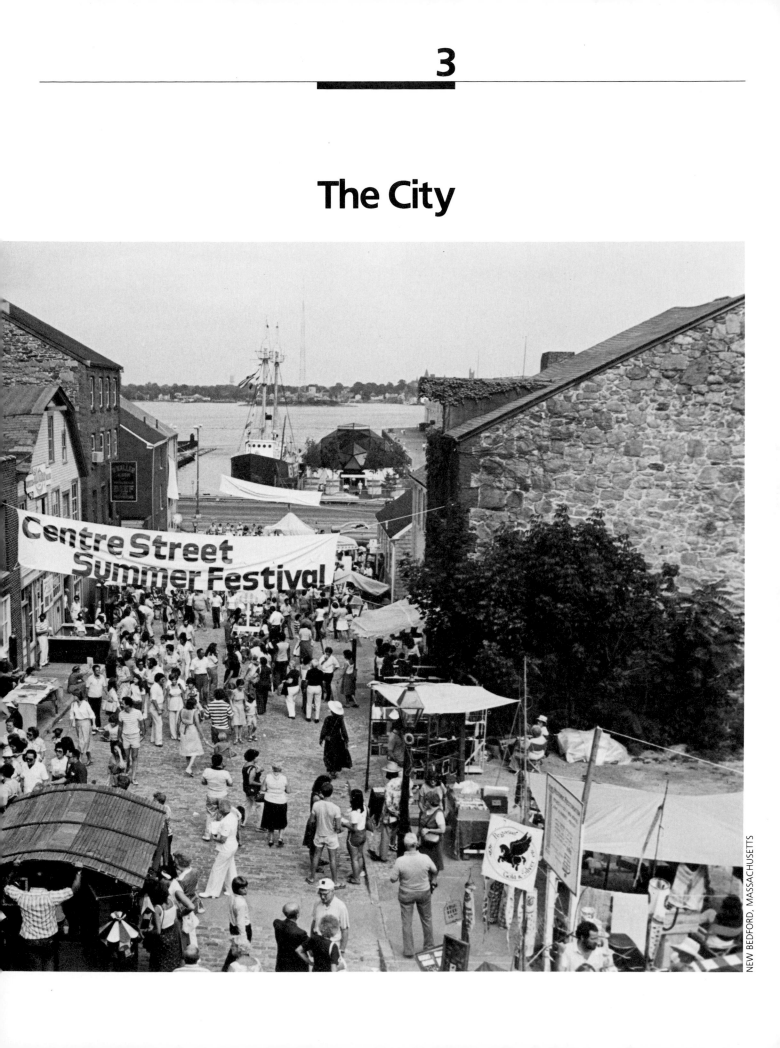

City Scenes

A city's information packet is the tourist's menu of places to see, and an excursion bus tour is a visual smorgasbord. Hopping a tour is the quickest way to get an overview and select where you'd like to explore in depth.

Aquariums

Short of scuba diving, there is no better way to photograph live fish than to visit an aquarium. The viewing area is usually a glass wall below the water surface. The main light source is usually the sun.

Press your lens against a clean place on the glass to eliminate unwanted reflections. Take a light meter reading with the meter facing toward the bottom of the tank. Use this setting, and not one taken looking up toward the surface.

No filtration is needed for black-and-white film. Color film, however, will take on a blue cast when used underwater. And the deeper the water, the bluer it gets. A CC30 red filter is a good general purpose filter to remove the blue cast under water. Below 30 feet, filtration is futile. The chart on page 84 will give you a starting point for exposure at various depths.

Flash produces vivid and sharp underwater pictures without filtration. If the aquarium will allow it, use your portable flash, especially in deeper water. Put the flash on manual, preset your focus at a logical distance for the shot, and then set the f-stop according to the distance scale on the flash. Press both the camera and flash flush against the glass for shooting.

BOSTON, MASSACHUSETTS

▲
Not all the action at aquariums is underwater. Seals, penguins, research boats, and kids are usually found topside.

▲
If you're quick and have prefocused your camera, you can get a picture of the fish before it swims away. Be patient and prepare to shoot a few extra frames to insure getting a good shot. (Photo by Janet Mendes)

Cathedrals

A pinnacle of artistic expression has always been architecture, especially cathedrals. Understandably, every city proudly exhibits its most famous domes, mosques, and temples.

Approach a cathedral exterior as if it were a landscape, using daylight film. Shoot from across the square or plaza, if there is one. Frame the entire cathedral with the plaza in the foreground. Activity in the plaza, such as flying pigeons or robed monks, will make your exterior photos more exciting.

The first thing you'll notice upon entering most cathedrals are the beautiful stained glass windows. Stained glass, illuminated by the sun, is best photographed with daylight film. The large dark areas surrounding the windows will mislead your light meter. To get a good exposure of the stained glass, take a close-up reading and lock it in. If a close-up is not possible, take an exposure for the light level found outside. Next, take three more shots, each time opening up the lens by one stop (for example, 1/125 at f/11 for outside, next shoot at 1/125 f/8, 1/125 f/5.6, 1/125 f/4). This is called "bracketing" your exposures.

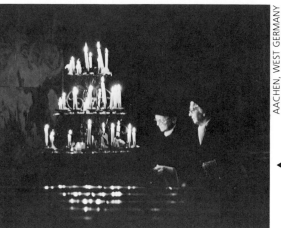

AACHEN, WEST GERMANY

◄ Be quick and be discreet when shooting church scenes. Use the available light instead of flash to preserve the mood and warm colors.

Large cathedrals often have candlelit alcoves. Use fast color film to compensate for the low level of existing light. Try to predetermine the exposure in an unoccupied alcove and lock it in. Now step back and, with a short telephoto, look for a worshiper lighting candles or in prayer. It may be necessary to steady your camera on a column or pew. Be discreet by not using a flash, not closing in, and not taking too many photos.

Colors inside a cathedral will be a warm yellow-orange when shot on daylight film. I find such a color cast a pleasing element to the candlelit environment. For accurate color rendition use tungsten-balanced color film with filtration.

In older towns, the cathedral often dominates the skyline. Don't overlook tours to the highest spire. It may take some trudging up winding old stairs, but the panoramic views are well worth the climb.

Cathedral Exposure Guide

	ASA/ISO 32	ASA/ISO 64	ASA/ISO 125	ASA/ISO 200	ASA/ISO 400	ASA/ISO 800
Interiors	1/4 sec., f/2	1/8 sec., f/2	1/15 sec., f/2	1/30 sec., f/2	1/60 sec., f/2	1/60 sec., f/4
Candlelit faces	1/2 sec., f/2	1/4 sec., f/2	1/8 sec., f/2	1/15 sec., f/2	1/30 sec., f/2	1/60 sec., f/2
Spotlit exterior	1 sec., f/2	1/2 sec., f/2	1/4 sec., f/2	1/8 sec., f/2	1/15 sec., f/2	1/30 sec., f/2

Cityscapes

Like landscapes, cities can be photo-graphed as a grand expanse or in meaningful detail. An old city can be pictured as both a field of crooked chimneys and a worn brass door-knocker. Whatever your approach is, applying a few simple techniques will show your city at its best. Professional travel photographers joke about shoot-ing at dawn, napping all afternoon, and shooting again at sunset. At these times the colors are exotic, shad-ows are defined, and everything looks special. Wait for dramatic light—it's worth it.

Find the highest observation point. It may be a building or a nearby mountain. Go there just before sunset and bring a tripod. Most people will be dining at that hour, so you won't be crowded. If shooting through glass, position your lens flush up against it to eliminate inside reflections. Draping a coat over your head and the camera will also help with reflections. Lock in a meter reading of the ground below if you want detail to show there. For a rich sky at sunset, take a reading of the sky, but be aware that the ground will come out dark. Gray tinted glass will not overly affect your color pictures, and your camera's built-in light meter will automatically compensate.

Haze is the biggest problem in city-scape photography. It is so bad at times in New York City that objects more than 500 feet away lose their color. All haze reduces color satura-tion, an effect that increases with dis-tance from the camera. A polarizing filter is the most effective means of eliminating haze. But when it's really bad, getting as close to your subject as possible works best.

As the sun dips below the horizon, the wind stills, and the fiery colors in the sky turn to a purple wash. Find a place where the city is reflected in a lake or river. Use a tripod and day-light film. The sky, the lights, and possibly some small boats will cast per-fect images in the still water.

In New York City, my favorite vantage points for photography are high and low places. The highest is on the open deck of the World Trade Towers, visible at the top of this photo. The lower view, from which this photo was taken, is from the promenade in Brooklyn Heights.
▼

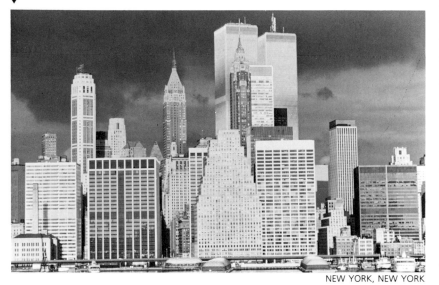

NEW YORK, NEW YORK

Sunset Exposure Guide

	ASA/ISO 32	ASA/ISO 64	ASA/ISO 125	ASA/ISO 200	ASA/ISO 400	ASA/ISO 800
Sunset	1/60 sec., f/5.6	1/60 sec., f/8	1/125 sec., f/8	1/250 sec., f/8	1/250 sec., f/11	1/250 sec., f/16
10 minutes after sunset	1/60 sec., f/2	1/60 sec., f/2.8	1/60 sec., f/4	1/125 sec., f/4	1/125 sec., f/5.6	1/250 sec., f/5.6
Night skyline	5 sec., f/2	2 sec., f/2	1 sec., f/2	1/2 sec., f/2	1/4 sec., f/2	1/4 sec., f/2.8

At Night

Cities are dancing with colorful light at night, doubly so after a rain. Many photographers overlook nighttime photography, mistakenly thinking there isn't enough existing light. But remember—if you can see it, you can photograph it!

For brilliant reds, oranges, and yellows at night, use daylight film. Indoor film will produce more accurate, but less colorful, lights at night. A tripod will be necessary no matter what kind of film you'll be shooting, so use a quality medium-speed film (like Kodachrome 64). Use a cable release so you won't shake the camera when pushing the button. Bracket all exposures, using the Night Exposure Guide as your guide.

I view tripods with the same affection I do a clumsy old friend: they're a nuisance at times, but it's nice to have them when you need them. Sometimes I think tripods are manufactured with one leg shorter than the other

just to give them character. Find a small, lightweight, collapsible tripod that you're comfortable with. A traveling tripod should fit in your suitcase when compressed. My favorite tripod is shorter than the height of this page, and I never begrudge it space in my camera bag. Gitzo is a manufacturer of quality tripods of all shapes and sizes.

WASHINGTON, DC

▲
Many photographers find cities most beautiful at night. Night pictures require a small tripod and cable release in addition to your regular gear. Even if your exposures are a little off, you'll be pleasantly surprised by the results. (National Park Service Photo by M. H. Wurts)

Night Exposure Guide

	ASA/ISO 64	ASA/ISO 125	ASA/ISO 200	ASA/ISO 400	ASA/ISO 800
Entertainment districts, brightly lit streets	1/60 sec., f/2	1/125 sec., f/2	1/125 sec., f/2.8	1/125 sec., f/4	1/125 sec., f/5.6
Shopping districts, store windows	1/30 sec., f/2	1/60 sec., f/2	1/60 sec., f/2.8	1/125 sec., f/2.8	1/125 sec., f/4
Neon signs	1/30 sec., f/2	1/60 sec., f/2	1/60 sec., f/2.8	1/60 sec., f/4	1/125 sec., f/4
Floodlit buildings, holiday lights	1/4 sec., f/2	1/8 sec., f/2	1/15 sec., f/2	1/30 sec., f/2	1/30 sec., f/2.8
Traffic patterns	5 sec., f/8	5 sec., f/11	5 sec., f/16	10 sec., f/16	20 sec., f/16
Fireworks	B f/8	B f/11	B f/16	B f/16	NR
Full moon scenes	60 sec., f/2	60 sec., f/2.8	60 sec., f/4	60 sec., f/5.6	60 sec., f/8

City Celebrations

▲
The excitement generated by people having fun at city events can inspire your photography. Why not join in, using your camera to share the enthusiasm?

Festivities, Outdoor Markets, and Walking Streets

Festivities abound in cities with solidified tourism programs. As a by-product of urban redevelopment, tourists are coming back to the city in droves to shop, eat, and take pictures. City celebrations at home and abroad are happening constantly. Be on the lookout for them.

Traditional festivals, such as West Germany's Oktoberfest, are listed in travel magazines and newspaper travel sections. Lesser known festivals can

be found in regional travel guides and local tourism packets. For large internationally known events, like the running of the bulls in Pamplona, accommodations should be reserved well in advance.

Outdoor markets and walking streets are festivals that take place nearly every day. Urban magic happens when an old historic district is recobbled and manicured, or a commercial wharf is refitted for recreation. Here are the showplaces for innovative architecture. Most urban malls are a carefully balanced mixture of plenty to see, eat, and buy.

Walking streets and outdoor produce markets are photographic free-for-alls. Atriums, alleyways, jugglers, vendors, and strolling musicians make ample visual offerings. Bring a short telephoto lens (85 mm, 105mm, or 135mm) for candids and alleyway shots. Look for flower cart close-ups and colorful fruit displays. Vendors don't mind photographers—especially if you buy something! A wide-angle lens (24mm, 28mm, or 35mm) will be useful for overall market scenes. Overalls are more effective if you can get above the crowd: stick your head out of an upstairs shop window, stand on a bench or stairway, or prefocus your camera and hold it over your head.

When the Tall Ships ▶ come to town, the whole city breaks out in celebration. The best place to photograph the ships is from another boat. If you're shooting from the shoreline, stake out a good position early in the day.

NEW YORK, NEW YORK

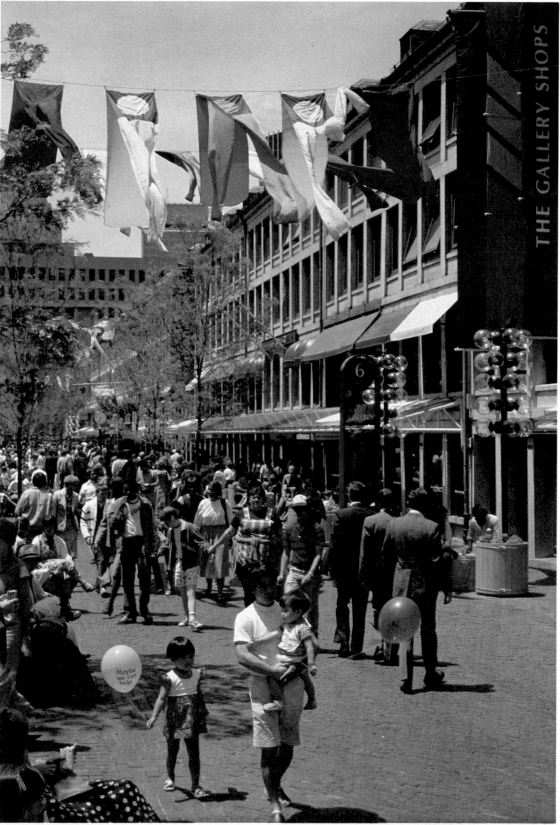

THE GALLERY SHOPS

BOSTON, MASSACHUSETTS

◄ After Disney World, Boston's Quincy Marketplace is the most visited tourist site in the United States. Redevelopment of commercial and waterfront districts is happening the world over, creating new photo opportunities in the city.

Gardens, Parks, and Zoos

Gardens and Parks

We city people treasure our parks and gardens. In these havens one can shed the hurry and relax. Photography comes easy here, because a park is designed for visual pleasure. Bring your camera, you won't be the only one.

A good warm-up when first photographing a park is to concentrate on its natural features: flowers, squirrels, trees, and such. Next, look for people enjoying the environment. You'll see children at play, couples strolling down garden paths, an oldster sunning on a bench. When you've got a good feel for the park, try integrating the city itself into your photos: buildings rising up in the distance over the parkscape, escapees from the rat race, or the hustle and bustle rushing by the serenity of your park.

Some city parks are carnival-like, like Tivoli Gardens in Denmark. Daytime photography might include rides, animals, and outdoor cafes. At night amusement parks take on a flashy sheen, with colored lights, dancing fountains, floodlit palaces, and fireworks.

In the United States, we have a new concept for city parks. The city itself, or a part of it, is developed into an urban park. Lowell, Massachusetts is the first National Historic Park. One may tour old textile mills, explore workers' rowhouses, or boat through the locks and canals. There are also National Urban Parks in New York City, Boston, and San Francisco.

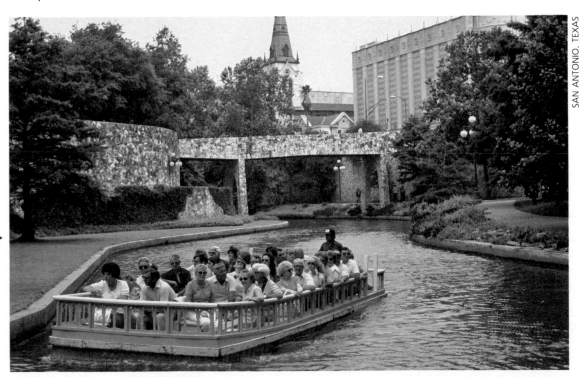

SAN ANTONIO, TEXAS

The city of San Antonio ▶ has developed a unique park. The Riverwalk accompanies the San Antonio River as it winds its way lazily through the heart of downtown. Both banks are lush with tropical plants, lined with restaurants and outdoor cafes, and teeming with visitors.

Zoos

Zoos are ripe territory for observing animals and people. The trend toward natural environment zoos (no bars) has been a boon to photographers. Animals always look better with nature all around them. Avoid including man-made objects, such as concrete and steel, in your zoo photos and they will be almost indistinguishable from the real thing.

Zoom and telephoto lenses are necessary for taking close-up shots of animals. Cropping in close with a telephoto will result in more dramatic animal pictures, and also makes it easier to exclude distracting backgrounds. The shallow depth of field of telepho-

TAMPA, FLORIDA

◀Because of their colors and approachable nature, parrots are great zoo subjects. And when the weather is warm you'll find them out in the sunlight.

tos can also eliminate distracting foregrounds. When a chain-link fence separates you from the lions, open up the lens (use a large aperture—f/2, f/2.8, etc.) and put the lens up to the fence. The chain links will practically disappear. Use a skylight filter to protect the lens surface from the metal fence.

Patience is the key to animal photography. You may have to wait a while for your favorite beast to poke his head out of his lair. And just like people, animals run a whole range of expressions and activities over a period of time.

ASHEBORO, NORTH CAROLINA

◀The photographer often has little control over camera-to-subject distance in a zoo. Zoom lenses prove useful for framing animals as they move about their habitats. With a zoom or a telephoto lens, you can judiciously crop out artificial backgrounds and include only the natural elements.

The Circus
and Carnival

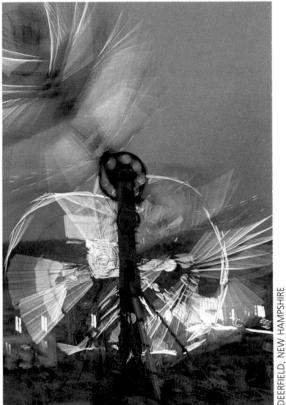

DEERFIELD, NEW HAMPSHIRE

▲
The best midway photos
start to happen after
the sun goes down. Set
your camera on a tri-
pod, away from the
crowds, and focus on a
multicolored ride. With
ASA/ISO 64 color film,
set your lens opening at
f/8. Now, using a cable
release, take several ex-
posures of the moving
ride at 1/2 sec., 1 sec.,
2 sec., and 4 sec.

TRINIDAD

▲
If your timing is right,
you can be in Trinidad
for Carnivale. (Photo by
Eric Nilsen)

Fast films, long lenses, and a quick eye are the tools you'll need for photography under the big top. Unless you have a spot meter (a light meter that reads a very small area), you'll have to estimate exposures for the spot-lit acts. A brightly lit high-wire act surrounded by a black background will throw off your light meter. Use the chart below, and bracket your exposures.

Special "push" processing of film will enable you to use faster shutter speeds and obtain sharper pictures at the circus. Kodak and other processors will specially develop your film to yield a higher ASA/ISO number. Thus, you may choose to shoot Ektachrome 400 at ASA/ISO 800 or even 1600!

Most sideshows, games, fortune tellers, beasts, and clowns pose exciting picture possibilities. Look for carnival colors on banners, posters, and tent murals. Amusement rides photographed at night with long time exposures can be spectacular.

Circus and Carnival Exposure Guide

	ASA/ISO 32	ASA/ISO 64	ASA/160 125	ASA/ISO 200	ASA/ISO 400	ASA/ISO 800
Overall circus	1/15 sec., f/2	1/30 sec., f/2	1/60 sec., f/2	1/60 sec., f/2.8	1/125 sec., f/2.8	1/250 sec., f/2.8
Spotlight	1/60 sec., f/2	1/125 sec., f/2	1/250 sec., f/2	1/250 sec., f/2.8	1/250 sec., f/4	1/250 sec., f/5.6
Midway, rides	1/8 sec., f/2	1/15 sec., f/2	1/30 sec., f/2	1/60 sec., f/2	1/125 sec., f/2	1/125 sec., f/2.8
Blurred rides	2 sec., f/8	2 sec., f/11	2 sec., f/16	1 sec., f/16	1/2 sec., f/16	1/2 sec., f/32

◄Look for the unusual at carnivals and arcades. Here, a short telephoto lens (85mm to 135mm) nicely framed the stuffed animals at the game booths.

TOPSFIELD, MASSACHUSETTS

Architecture and Details

A city's style of architecture reflects its character, be it the glass and steel newness of Houston, or the beehive of colors in downtown Tokyo. Without question, a wide-angle lens is the best tool for photographing city architecture. Very often a normal lens won't fit a large building in the image area, unless you can back up across a park or plaza. For pictures of the old city with narrow crooked streets, use a 24mm, 28mm, or 35mm wide-angle lens.

Wide-angle lens distortion is especially evident when you photograph architecture. When the lens is pointed upward to shoot a tall building, the vertical sides of the building appear to tilt toward the middle of the picture. If it is important to you to have parallel vertical sides on your architecture, you can try two things: 1) shoot from a position high enough to keep the lens pointing parallel with the ground and still cover the building; or 2) buy a wide-angle "perspective control" lens. Designed specifically for architectural photography, this lens has a rising front that will frame tall buildings without tilting the lens up.

Creative framing can be used to highlight architecture. Look for arch-

Left: a 35mm lens, pointed up to include the expanse of a tall building, shows wide-angle lens distortion. Notice how the outside walls slant in. Right: a 35mm perspective-control lens allows you to shift the front element of the lens up instead of tilting the whole camera. Distortion is eliminated.

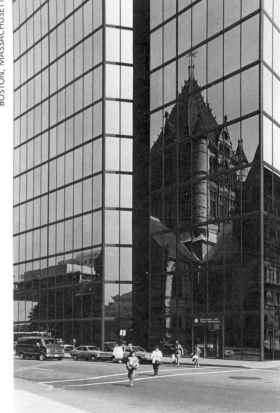

BOSTON, MASSACHUSETTS

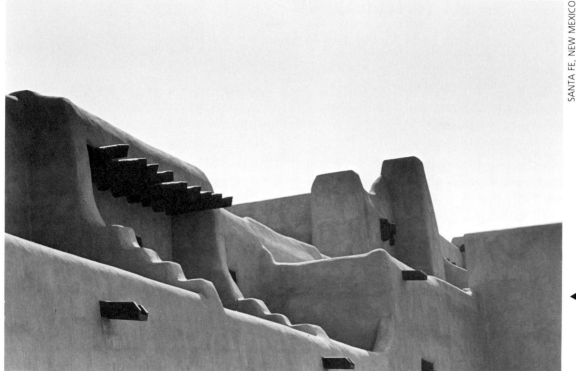

SANTA FE, NEW MEXICO

◀ Spanish adobe architecture contributes to the charm of Santa Fe. Details of adobe construction say as much about Santa Fe's character as any street scene.

ways, bridge spans, and rows of support columns. Shoot through old rippled windows, lace curtains, fancy grillwork, flower beds, and tree blossoms.

Reflections in windows, puddles, chromed automobile ornaments, and brass door fixtures are a creative way to picture a city's image. Use a 50mm or wider lens, stopped way down (f/16 or f/22) for lots of depth of field. Focus on the reflecting object—note the distance on the lens. Focus on the reflection—note that distance. Using the depth-of-field scale on the lens barrel, set the focus so that the near and far (reflecting object and reflection) are both in focus.

Architectural close-ups underscore a city's unique cultural identity. With a macro lens or a close-up attachment (see pages 74–75 on close-up photography) you can highlight details such

as cobblestones, boot scrapers, mail boxes, sewer covers, and flower boxes. Close-ups can really spice up a slide show or wall display when mixed with your other photos.

Speaking of recording details, an often overlooked travel photo is the sign. Signs contain information, philosophy, humor, and certainly a cultural flavor if you find the good ones. Shoot a sign instead of taking notes or saving brochures. I collect pictures of novel license plates and ethnic variations of the omnipresent Coca-Cola sign. The funniest signs I've seen are at carnivals. Take home all your favorite signs—on film!

Museums

Most museums allow picture-taking, though usually visiting exibitions are off limits. They also frown on the use of tripods and flash units. Fast tungsten film will give acceptable results under track and tungsten-bulb lighting. If window light is the main source of illumination, use daylight film with an 85C filter or an 85B+85C filter with tungsten film.

A polarizing filter will help eliminate reflections on varnished paintings or artwork framed under glass. The best way to avoid reflections when shooting an object in a glass case is to put the lens right up close to the case itself. No polarizer is necessary when you do this.

Today's museums are a whole lot more than paintings and old statues. Interactive, or "touch and do," exhibits make museums fun for the kids too. And the variety of museum collections has become astounding. There are airplane museums, auto museums, children's museums, farming museums, railroad museums, whaling museums, and even witchcraft museums! Check local listings for special events at museums in the area you are visiting. Museums also have outdoor offerings. Look for courtyards, Japanese gardens, and sculpture out on the lawn. You'll find museums with cafes and restaurants, movies, concerts, and make-your-own artwork festivals. Even if you don't see a chance to take some good photographs in a museum, the visual enrichment you soak in should inspire your picture-taking later.

Before leaving a museum, don't forget to investigate the gift shop. Museum gift shops carry a rich selection of quality items that would take a seasoned shopper weeks of footwork to find elsewhere. In addition to buying great gifts in one spot, you're helping to support a museum.

◄ Boston's Children's Museum and Museum of Transportation. Adults are welcome.

A special exhibit of the ► world's largest Monopoly game at the Essex Institute.

BOSTON, MASSACHUSETTS

SALEM, MASSACHUSETTS

◀ Yes, it's OK to climb aboard. New Bedford Whaling Museum.

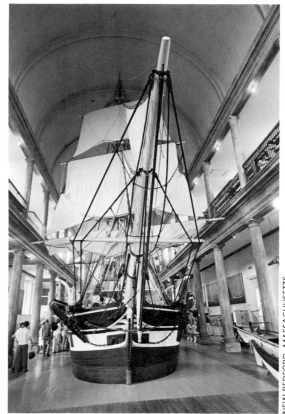

NEW BEDFORD, MASSACHUSETTS

ASHEVILLE, NORTH CAROLINA

◀ The Southern Appalachian Folk Art Center is a museum of folk art. It also provides an outlet for local craftspeople, demonstrations by folk artists, and is an information resource for the Great Smokey Mountains.

◀ Interesting pictures result when museum-goers relate to the art-work, as this women is at the Boston Museum of Fine Arts. Investigate the sculpture garden for this kind of activity. (Photo by Ulrike Welsch, Courtesy of *Boston Globe)*

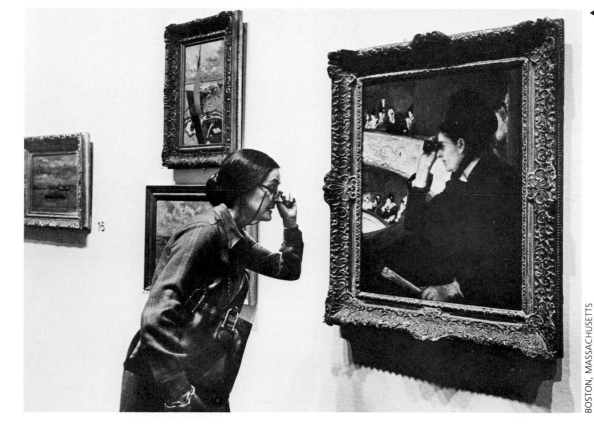

BOSTON, MASSACHUSETTS

Factory Tours

A region or a city renowned for growing or manufacturing something special probably offers factory tours. Most tours are free, gratis samples are not uncommon, and the factory bargain outlet is usually the last stop on the tour. Such programs build good relations with the public, and publicity-wise manufacturers are banking on you remembering them in the future.

Winery and brewery tours are common. In the harvest season one may tour not only vineyards, but also orchards, cranberry bogs, oyster farms, mushroom caves, and trout hatcheries. A zoom or a selection of lenses will allow you to stay with the tour group and frame a variety of subjects.

Offbeat tours can be the most fun: perfume factories, small Caribbean rum distilleries, steel mills, sewer systems, power companies, and so on. On indoor tours, shoot fast black-and-white or color film. Many of the tours I've been on have yielded good pictures without special access. Just stay with the group, shoot during the lecture, linger for one or two last photos, then catch up.

When you're in Copenhagen, don't miss the Carlsberg Brewery tour. Bring color film to photograph the copper brewing vats.
▼

J. C. JACOBSEN GRUNDLAGDE CARLSBERG 1847

COPENHAGEN, DENMARK

WANTAGH, NEW YORK

▲
Sewage treatment plants don't appeal to everyone, but the curious and the daring are well rewarded on these tours. Call ahead to the public relations department to schedule your visit. Some plants have lighted schematics of the treatment process and there's usually a free glass of water at the tour's end.

Foul Weather Photography

Probably 95 percent of all outdoor pictures are taken on bright sunny days. But there's no law against taking pictures when it's weathering out there, and you're likely to produce some beautiful, if not different, images for your efforts. All that's needed is to dress your camera for the weather conditions.

Wet fog, drizzle, or rain can damage an unprotected camera. Moisture will loosen lens elements, corrode flash contacts, and make havoc with the electronic circuitry. A UV filter will shield the front lens element and withstand continued wiping. Cover the camera body with a clear plastic bag. Stick the lens through a hole cut in the bottom of the bag and secure it with a rubber band around the lens barrel. The open end of the bag will allow access to the viewfinder and camera controls. When it's time to change the film, the bag can be peeled back until it's inside out and around the lens. In extremely heavy weather secure the open end of the bag with a rubber band.

Falling snow can also drown your camera—especially if it's wet snow. Use the above-mentioned camera raincoat. Wipe off any snowflakes or water droplets that fall on the lens with a soft cloth just before taking a picture. Otherwise they'll show up as little blur patches. Don't forget that falling snow will photograph differently according to the shutter speed used. A fast speed will show the individual flakes suspended in the air. A slow shutter speed will cause the snow to appear as a white streak or disappear altogether!

Extreme cold, even when unaccompanied by snow, can cause camera problems. Cold temperatures weaken batteries and freeze lubrication. Some electronic cameras will not function at all when they're very cold. The solution is to nest the camera under your coat until you're ready to shoot. Some camera manufacturers offer remote battery extension cords, which enable the photographer to keep the batteries warm and under his or her coat while shooting.

A cold-soaked camera coming into a warm, moist room will fog up just like grandpa's glasses. Even worse, condensation can take place inside the camera and lens. Don't let your camera get too cold and wrap it in a plastic bag while still outside. Take the camera out of the bag after it has thawed out and condensation will not be a problem.

A camera in its raincoat. It can be carried in an empty film cannister in case of snow, rain, or heavy dust. The rubber band and plastic bag cost less than 5 cents. ▼

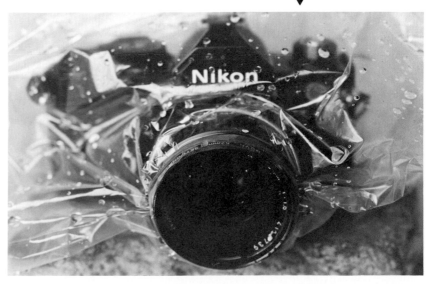

Your most cherished travel photos will be of people. The revealing portrait with the telling glance and the universal emotional expression is a gem among photographs. Photographing people isn't easy: they don't hold still, they blink, they squint. And if you don't know them, they may walk away. But people are so interesting that even if you think you've failed, your people pictures will be a significant part of your trip. (Photo by Lisa A. Faneuf)

4

The People

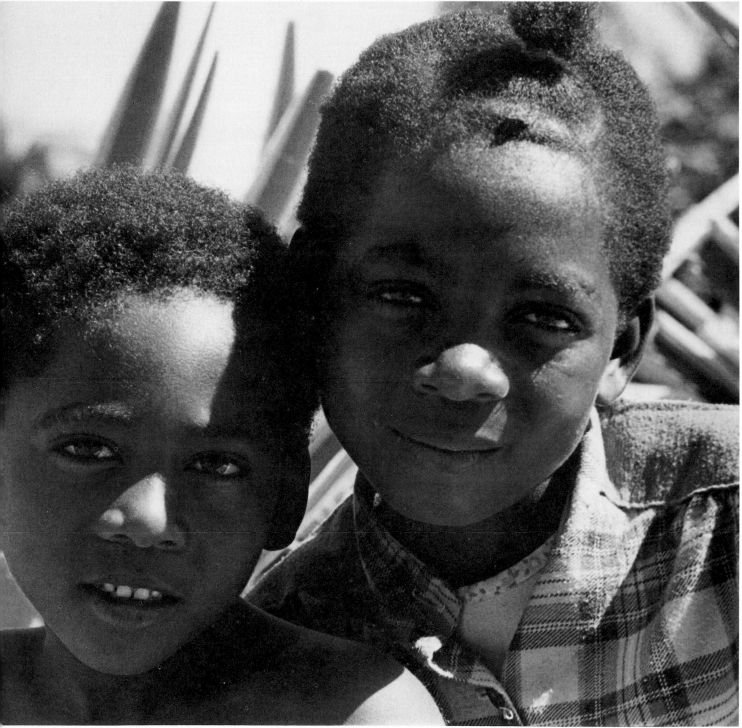

Street Photography

Unless you're up with the milkman, people are going to be in your city photos. People are part of the natural street scene: workers, merchants, children, and tourists. An overall street photograph does not directly involve your subjects. They usually think you're shooting the larger scene and rarely do they object.

People enjoying themselves in city parks usually don't mind a photographer. Relax, smile, and be a friendly observer. (Photo by David Aronson)
▼

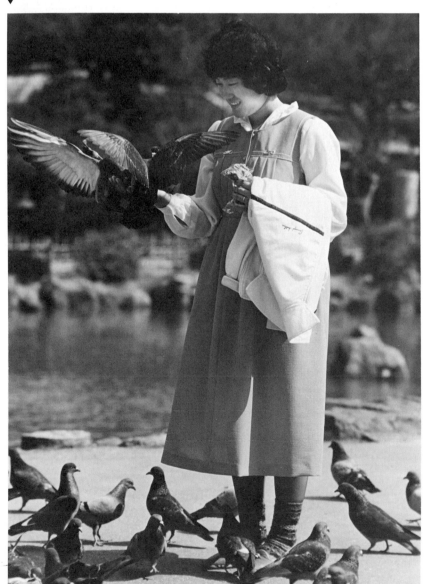

TOKYO, JAPAN

When shooting a street scene, be careful not to snap the picture as a nearby pedestrian or automobile enters the scene. A moving object close to the camera will probably be out of focus and distracting. Many times I've had to reshoot a scene because of an unexpected intruder. Observe, be patient, and get a clear shot.

Focusing in on one person on the street may seem awkward. It is never easy, but every traveling photographer wants to take a good candid. So how do you comfortably approach a perfect stranger, who may not even speak the same language as you, for a picture?

Ask: Hold up your camera and say: "Do you mind?" or "May I?"

Comment: Remark on how interesting you find your subject's activity. Then pop the question: "I'd love to photograph this!" Hopefully, their enthusiasm will match yours.

Act Natural: Smile, pick up your camera, and shoot. This works with very busy people and friendly people.

Blend In: Your subject may be aware of your presence, but accept it because you've become part of the scene. Observe. Shoot other surrounding subjects.

It's natural to have some "camera fright" when photographing strangers, especially in foreign surroundings. Be honest, direct, and friendly. Loosen

up by shooting nonthreatening pictures first. With time and practice, you'll master candid photography.

Using the right lens can help you get the candid shot you're after. With a telephoto lens you can get a tight head shot of your subject without having to move in too close. But it's difficult to focus a telephoto quickly and it's even harder to hide the long lens from your subjects.

A wide-angle lens can also be effectively used to candidly photograph people. While a telephoto must be aimed directly at the subject, a wide angle, because of its extensive angle of view, can be pointed significantly off-target and still include the subject. With a 24mm lens, for example, the colorful foreground might appear to be your objective, while your real subject is framed quite nicely in the background.

COPENHAGEN, DENMARK

RIO NEGRO, COLOMBIA

◄ Street scenes look better when your subjects are unaware of the camera. Because of its wide angle of coverage, a wide-angle lens will allow you to include subjects without pointing the lens directly at them.

▲ Walking streets have plenty of action. A wide-angle lens works best in such close quarters, and presetting your exposure and focus will prepare you for some quick shooting.

Portraits on the Road

There is a collaboration between photographer and subject in portrait photography. Both exercise some control over the posing, location, and expression that help to create the desired result. You'll want to remember your fellow gadabouts and hosts with portraits.

HAKONE, JAPAN

▲ This group is carefully arranged to show everyone's face. The picture also includes the reason why they're all there—Mount Fuji, in the background. Be it the Statue of Liberty or Buckingham Palace, pose your group near it, on it, or in it. (Photo by Barbara London)

After asking the engineer of the Edaville Railroad if he would pose, I took his head-and-shoulders portrait with an 85mm lens. I asked him to lift his head to shorten the shadow under the brim of his hat and look into the camera. ▶

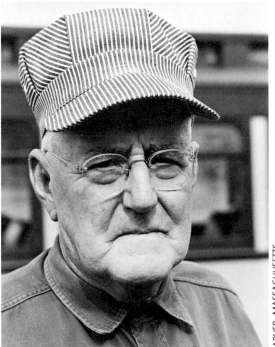

CARVER, MASSACHUSETTS

Head-and-Shoulders Portraits

A close head or head-and-shoulders portrait should be shot with an 85mm or 105mm lens. A wider lens will cause some distortion of the face at close range. Find an even, undistracting background. Avoid pinning your portrait subject right up against the background, unless it's supposed to be part of the picture.

Good outdoor portrait lighting has to be found. Direct sun on the face will cause squinting. Severe backlighting puts too much light on top of the head and too little on the face. Bright sidelighting can leave one side of the face in dark shadow.

Cloudy days provide good portrait lighting, as does early-morning or late-afternoon light. Windows, with plenty of diffused light coming through them, also provide soft portrait lighting. At high noon shoot your portraits in the shade of a tree or a building. Remember to take a close-up exposure reading of just the face, and compensate the exposure according to the skin tone of your subject (see page 25).

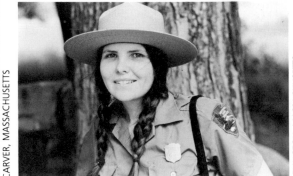

LEXINGTON, MASSACHUSETTS

Environmental Portraits

More information than just the subject's face is included in an environmental portrait. Your subject's body language, surroundings, tools, and activities become important. The environment is used to make a total portrait statement. A blacksmith, for example, could be pictured in his apron holding a hammer and horseshoe. Or the environmental portrait could be expanded to include him leaning on his anvil, or actually pounding a horseshoe with sparks flying. Short telephotos and normal lenses are best suited for the closer environmental portraits. When more of the surroundings are desired in the picture, a wide-angle lens works best.

Group Portraits

Good posing and interesting backgrounds liven up group photos. Groups larger than a small family should not be posed in a straight line. Find a bench, a low wall, stairs, a climbable statue or tree, or a hillside. Put the tall people in the back and if it's really crowded, ask the front row to kneel. Check to make sure that nobody's face is hidden before you take the picture.

Waist Up and Horizontal Portraits

Step back from your subject, and you can make a nice portrait with your normal (50–55mm) lens. The background will occupy more space than it would in a tight head shot and it may be more in focus—so make sure it's plain or at least a pleasant comment on the location.

Don't be afraid to make a horizontal portrait. Changing the portrait format can be a relief from the standard head-to-toe portrait. Try putting the sitter off to one side and the landscape on the other.

Portraits of couples work well as horizontal photographs. Get them close together and tilt their heads.
▼

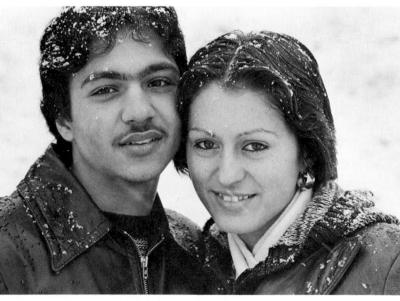

JAMAICA PLAIN, MASSACHUSETTS

◀ An environmental portrait says something extra about the subject. The uniform, the hat, and the tree express this woman's occupation as a park ranger.

Children

Fortunately for travel photographers, there are special people scattered all over the globe who willingly model and act for us—children. They will ham it up or be serious, make monkey faces, and even ask to have their pictures taken. All children are photogenic (especially if they're our own) and they're just waiting for us.

It may look silly, but a ► "Child Charmer" hot-shoe attachment will raise a grin out of all but the crankiest children.

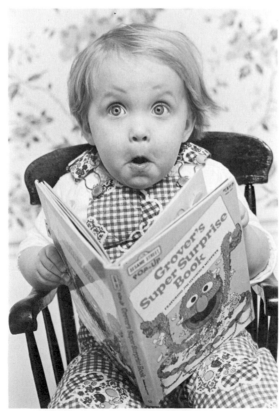

Time, patience, and in- ► genuity are all required in child photography, but the rewards are great. It also helps if you like kids!

Patience is the key to unposed looking photographs of children. Thinking they're being cooperative, kids will mug for the camera. Granted, these silly grin shots are cute, but there's a limit. Photographers must wait out their subject's antics, and then become a director and observer.

First, establish a rapport with the child. Approach him or her slowly, openly, and with a smile. If the parents are nearby, ask their permission, especially if you intend to take a lot of photographs. Most parents are flattered to have their children photographed. An instant camera in this kind of situation will make you a "star" on the spot.

Next, make your little subjects into accomplices by conspiring with them to get the kind of picture you want. For candids, ask them to pretend you're not there. For a specific activity or expression, simply ask them to go about it like an actor. Directions work, believe it or not, with kids as young as two.

Always remember that children are sensitive, but curious, human beings. Don't tower over them—get down to their level for conversation and for photography. Kids tire quickly when taking directions. Shoot quickly and let them go on their way. But don't be shy about photographing children; they think it's fun!

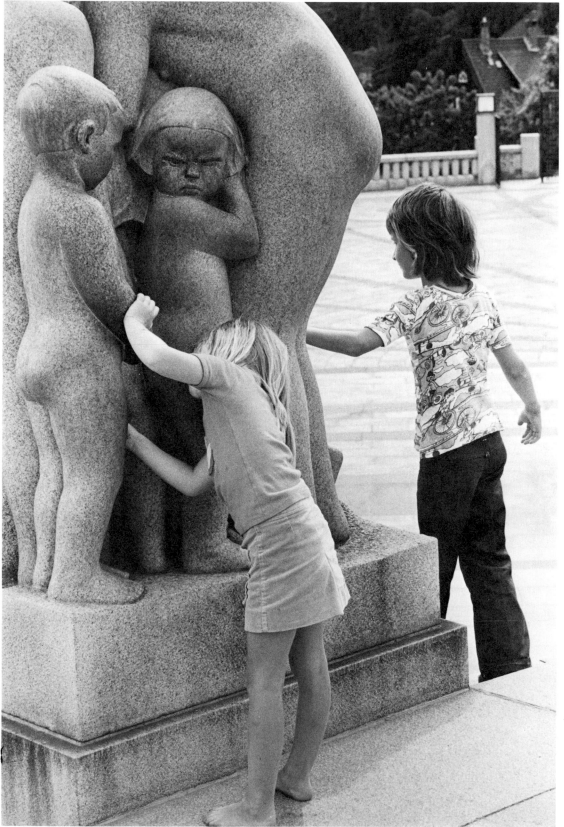

OSLO, NORWAY

◀Children are at their best when they act natural. Oslo's Frogner Park sparked numerous interactions between the sculpture and the curious. The most productive photo technique is to wait, watch, and shoot.

Historic Re-creations

Historic re-creations of all kinds and sizes are happening worldwide. They are located at permanent sites, such as the historic settlement of Williamsburg, Virginia, and occasionally an entire city gets into the act for a holiday or historic anniversary. Authentic architecture and furnishings are available for close inspection. Add a staff dressed and reenacting a historic period and you've got a virtual time machine for photographers.

The blacksmith, the hatter, the farmer, and the innkeeper all ply their trades in restoration villages. Their job is to live in the past for the visitors, who ask questions and take pictures. If it's not too crowded, you might have a very enlightening talk with an eighteenth-century sea captain. And I'm sure you'll get some memorable pictures too.

Window light usually illuminates these historic actors. For an authentic effect, use the natural light instead of flash. Candles and oil lamps will add to the flavor. Be selective in your choice of backgrounds: other visitors or twentieth-century fixtures will spoil the mood.

Activity also continues outside. With some patience and forethought you can photograph housefronts, streets, and gardens without modern people intruding. Be on the lookout for special moments out of the historic time: two bonneted ladies bustling across a field, the farmer leaning on his hoe, or an old wagon pulling down a dusty road.

Many historic re-creations host special events for the holidays. At Christmas, you might find yourself in a punch lantern procession, or hearing ballads in an old upstairs tavern, or sampling a hearth-roasted pig. These occasions are priceless photo opportunities and adventures, above and beyond the guided tour. Public celebrations are listed in area entertainment guides and can also be discovered by calling historic establishments.

Corral at the Hubbell ▶ Trading Post. Hubbell is an Indian trading post. It sells their crafts to visitors. It is a National Historic Site which operates much as it did 100 years ago.

GANADO, ARIZONA

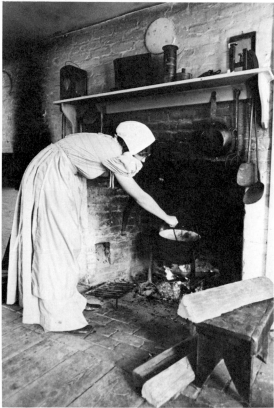

A historic re-creation is like an authentic movie set just waiting to be photographed. At Bethpage Restoration, one can view baking, building, cobblery, farming, livestock, quilting, and much more. Not only will the participating re-enactors pose for you, but they'll tell you first hand what it's like to live in another era.

Sports

Travelers encounter sport events wherever they go. From professional games in the arena to "fooling around in the park," photographers have their choice of the action.

At professional sporting events, amateur photographers may not be allowed up to the sidelines. Excellent photographs can be made from the railing or from your seat with a long lens. At major league baseball games, for example, the photo press box is set back over the foul-line seats. If the game is held at night ("under the lights"), use a fast tungsten film. Base your exposures according to the guide below.

The advice of professional sports photographers is to never take your eye from the viewfinder or your finger from the shutter release. Use a long lens, fast film, and follow the play with your camera. (Photo by Pam Price)
▼

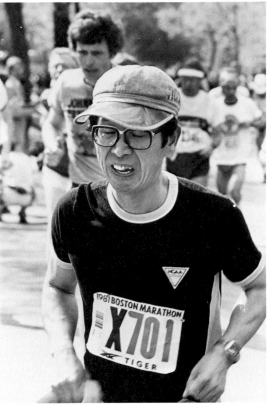

BOSTON, MASSACHUSETTS

▲
It is easier to get a sharp picture when motion is coming directly towards you. Stopping the action becomes increasingly more difficult as the camera position approaches a right angle to the direction of motion.

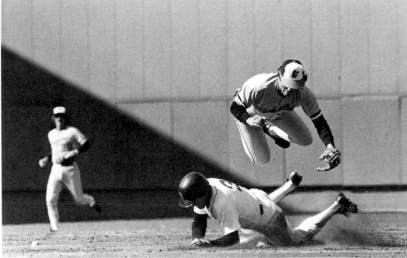

BOSTON, MASSACHUSETTS

Night Sports Exposure Guide

	ASA/ISO 64	ASA/ISO 125	ASA/ISO 200	ASA/ISO 400	ASA/ISO 800
Brightly lit stadium events	1/60 sec., f/2	1/125 sec., f/2	1/125 sec., f/2.8	1/250 sec., f/2.8	1/250 sec., f/4
Pro gymnasium events, basketball, hockey	1/30 sec., f/2	1/60 sec., f/2	1/125 sec., f/2	1/125 sec., f/2.8	1/250 sec., f/2.8
School gymnasium events	1/30 sec., f/1.4	1/30 sec., f/2	1/60 sec., f/2	1/125 sec., f/2	1/125 sec., f/2.8

Instant Friends

Instant cameras are traveling with us. They are now the main camera for many travelers. And you've got to admit that it's thrilling to see your travel photos minutes after they're taken. You can actually fill up an album as you tour.

In addition to instant visual gratification, instant cameras can make instant friends. Outside the United States and Western Europe, instant cameras are rare. The magic of the process itself may make you the center of attention. And even in locations where instant pictures are not such a novelty, a gift print is appreciated. Professional photographers carry instant cameras as ice breakers. Fellow travelers and native residents make themselves willing subjects when they're on the receiving end of your instant photography.

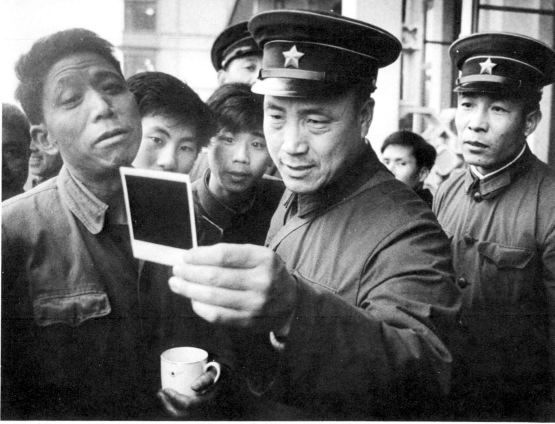

◄ One of the rewards of instant photography is seeing your subjects' response to their picture. On the spot photo gifts will make instant friends, and who knows what other photographic avenues will unfold? (Photo by Joe Wrinn)

PEKING, PEOPLE'S REPUBLIC OF CHINA

The landscape has al- ▶
ways been a major pho-
tographic topic. It is the
most approachable and
obvious subject, yet one
of the most challenging.
Landscapes are not only
the lay of the land, but
also the weather, time
of day, and nature's
detail.

5

The Land

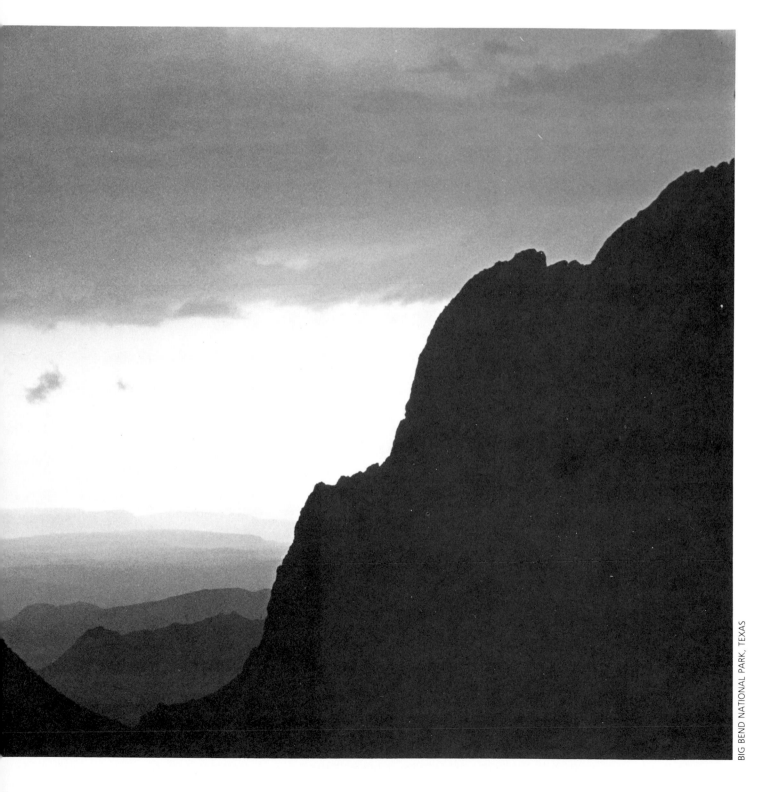

At the Shore

More cameras go to the seashore than anywhere else. And understandably so; the oceans have carved out such intricate and fascinating coasts. Rustic, rugged, settled, or sandy, the waterfront is the travel photographer's best friend.

Exposures

Sand, sea, and sky will all cause your light meter to read one or two stops toward underexposure. This is because your light meter is influenced by the great expanse of brightness and will give a reading to expose as a gray tone. Everything will be underexposed and appear too dark in the photograph. If your pictures at the beach have been coming out dark, compensate by using the +1 or +2 setting on your automatic camera or locking in a light reading taken off a neutral gray subject.

▲
Windblown sand, spray, and surprise dunkings pose constant threats to your camera. Using an underwater camera takes the worry out of beach and boat photography. Take it along on canoe and white-water rafting trips.

Bright sand will photograph as middle gray unless exposure compensation is made. The +1 or +2 setting on your automatic camera will usually make the correct adjustment.
▼

Seacoast Camera Protection

The rugged seacoast may be a photographer's visual delight, but sand and salt can be your camera's undoing. Rather than pass up the opportunity to take beach pictures, some photographers buy underwater cameras (see pages 82–83) just for that purpose. By taking a few protective measures, however, you can safely photograph at the shore with your normal equipment.

First, keep your equipment wrapped in a large plastic bag when not in use. Be sure your hands are not salty or sandy when handling camera or lenses. If it's windy or wet, dress your camera in a home-made rainbag (see page 53), or even better, buy a $60 EWA "Space Suit" for your camera (see page 83).

Never try to change film outside on a windy day near the water. It only takes a little salt spray to corrode a camera's circuitry, and only a few grains of sand to start wearing the bearings and gears. Change film in a car, beach pavilion, or cabin.

On returning from the beach, carefully wipe the outer metal surfaces of the camera and lens with a slightly dampened paper towel. Then use lens tissue and fluid to clean the lens and viewfinder. Rinse or discard the rainbag.

IPSWICH, MASSACHUSETTS

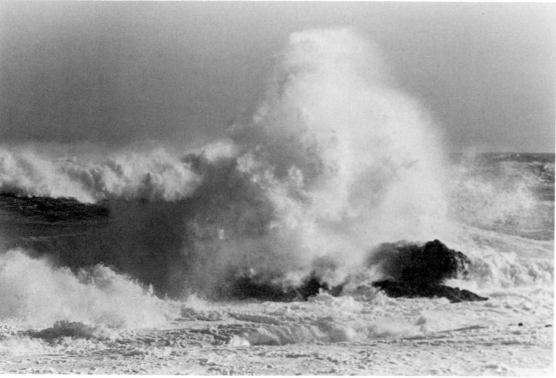

GLOUCESTER, MASSACHUSETTS

◀ It takes more timing than one would imagine to catch the "peak of action" in a wave. It can crash dramatically or quietly—no two waves break alike. For a spectacular effect, shoot a breaking wave using a tripod and a slow shutter speed.

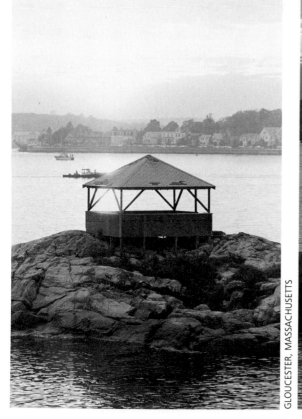

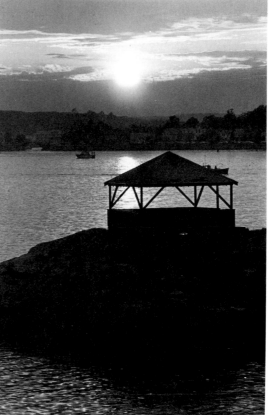

GLOUCESTER, MASSACHUSETTS

◀ Light shimmering off the water is beautiful and sometimes tricky to photograph. The shimmering effect is a reflection of the sun itself. The exposure will depend on what angle the sun is at, how wide an area the reflection occupies, and what kind of picture you want.

A normal daytime exposure will give good results when there's a little shimmering here and there. A lot of sun reflections may indicate a need for a shorter exposure (one or two f-stops less or the −1 or −2 setting on your camera) to capture some detail in the bright areas. A short exposure will cause surrounding water and land to come out dark or even silhouetted.

In the Mountains

BIG BEND NATIONAL PARK, TEXAS

▲
Because of their ex-
treme depth of field,
wide-angle lenses let
you include an in-focus
foreground in your dis-
tant landscapes.

There's a wilderness out there. A few
scattered villages, wandering roads, le-
gions of trees, surprise waterfalls, and
the landlords of it all—mountains.
Photographers who travel to the
mountains find something special: a
stationary subject that is always chang-
ing and a beauty so complex that the
longer you look, the more you find to
photograph.

The first challenge in mountain pho-
tography is getting there with your
equipment. Many dramatic picture
opportunities are a short hike from
your car or camp. To reach them with
a minimum of muscle ache requires
some specialized packing.

A short footpath hike is best photo-
graphed with one camera on your
shoulder and only as much equipment
as will fit in your pockets. If you'd like
to bring a sweater, extra lenses, and
lunch, try using a fanny pack or day
pack (see pages 12–13).

Long hikes or bushwhacking off-trail
demands more photo and survival
gear. A full-size frame backpack, with
photo equipment nested in with your
sleeping bag and socks, will probably
be necessary. CAUTION: Weather
conditions change rapidly and dramati-
cally in the mountains. Never hike
alone. Always leave word where your
party is hiking to and when you are
due back. And don't make your own
trail unless you are an experienced
backpacker.

Probably the most useful lens in
mountain photography is a moderate
wide-angle: 28mm or 35mm. It can

capture the sweeping vista from a rocky ledge and improve landscape compositions by including an in-focus foreground. In the forest a wide lens is needed to cover the expanse of a tall tree or the run of a waterfall down a narrow gorge.

A forest is surprisingly dark. It is not unusual to need a tripod in a dense forest when you're using a medium-speed film (ASA/ISO 64 or 125). And if the day is overcast, you'll be glad you packed a lightweight tripod. Only a reflective layer of snow on the ground below or leafless branches above will convince me to leave my tripod behind.

Patches of sunlight breaking through a forest's tree canopy present an exposure problem. The bright patches of sunlight and surrounding dark areas are beyond the range of most films; the detail cannot be recorded in both areas at the same time. Choose, or let your automatic camera choose, whether to expose for the high or low tones in the photograph.

When there is a lot of sunlit area, or if the most important subject is in the sun, I'll set my camera to expose those areas correctly. If the sunlight is limited to little pools here and there, I'll expose for the shade. It's also a good idea to bracket exposures in this situation, especially with color slide film.

 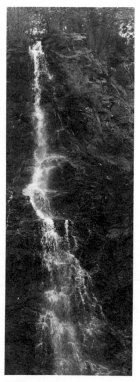 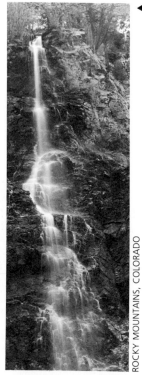

◀ Waterfalls and brooks can be "frozen" by using a fast shutter speed (1/1000, 1/500, 1/250 sec.), slightly blurred with a medium speed (1/125, 1/60, 1/30 sec.), or given an ethereal quality from a long exposure (1/15, 1/8, 1/4 sec., and longer) and the use of a tripod. A polarizing or neutral density filter will help block out enough light to permit the use of very slow shutter speeds.

ROCKY MOUNTAINS, COLORADO

1/500 second 1/60 second 1/2 second

On the Farm

People are coming back to the farm via farm tours and family farm vacations. These are great ways to see firsthand the details of farm life. Spending time on a farm can be relaxing, educational, fattening, and a picture story.

As you travel through farm country, farm landscapes will reveal themselves. To make a better picture, pull over and get out of your auto. Many good photos are lost as a result of momentum—the urge to keep on moving. Shots through windshields, with blurred guard rails or electric wires, don't compare with the carefully composed picture. Resist momentum. Practice will help you find just the right place to stop.

Rolling farmland, such as that of upstate New York or Pennsylvania, is easier to photograph than prairie. Barns and contoured fields tucked away on a hillside lend themselves to neat and interesting compositions.

Flatlands require a more creative effort. Don't just lay the horizon line down the middle of the picture and call it quits. Try shooting the big sky with a wide-angle lens. How about a late afternoon farm silhouette? Or find a tower where you can show the expanse of land.

▲
Farm animals are ready subjects. A short telephoto will fill the frame and help eliminate a distracting background.

Harvest season is the time to make pictures of crops in the field. Use a macro lens or close-up attachment (see pages 74–75) for "on the vine" close-ups. I sometimes bring a plant mister along to wash the dust off the produce. The water droplets remaining add a freshness to the photo. Blow-ups of your favorite crop close-ups make chic decor in the kitchen or dining room. ▶

LEXINGTON, MASSACHUSETTS

MIDDLETOWN, CONNECTICUT

▲
"U-Pick" farms are not only fun and pennywise, they also give the photographer visiting privileges to all kinds of fruit and vegetable farms.

◀ Roadside farms look best without guardrails, barbed wire, telephone lines, and drainage ditches. Walk up to the edge of the field and stick your lens over the fence, which is usually only 3 or 4 feet high.

WESTERN MASSACHUSETTS

◀ The diffused light coming in through open barn doors has made many a stunning magazine cover. Use this beautiful light for portraits, animal pictures, and country still lifes. Pleasant barn backdrops are hay bales, weathered barnwood, or the darkness receding farther and farther into the barn.

MT. DESERT ISLAND, MAINE

Nature Close-ups

One of the worlds that the camera discovers for us is the astounding detail in nature. A wet leaf is nothing special until a close-up photograph shows how every droplet magnifies and glistens. Close-ups are easy to make with your single-lens-reflex camera, and the needed accessory equipment can be inexpensive.

Supplementary close-up lenses thread onto the front of your normal lens, just like a filter. They are usually sold as sets of +1, +2, +3, and +4 diopters (magnification strength). The close-up lenses can be used separately or combined for greater magnification. No exposure increase is necessary with supplementary close-up lenses.

Extension tubes are a close-up attachment that fits between the camera and lens. They also come in various strengths of magnification, the longer ones magnifying more. Some exposure compensation is necessary when using extension tubes.

Inexpensive extension tubes do not couple with your camera's automatic mechanism. If you are using the meter built into your camera, you have to

CANTON, MASSACHUSETTS

manually set the f-stop for metering and exposure after focusing (called "stop-down metering"). An extension tube that couples with your camera's automatic functions costs more, but is worth the convenience for having the camera compensate for the tube being used.

Macro lenses are the most convenient and also the most expensive close-up tool. A macro is a lens which focuses close up and far away without any attachments. Some photographers replace their normal lens with a macro of the same focal length.

A good macro lens will couple with your camera's automatic functions. Exposure increases required for macro

Close-up photography is ▶ simple with a macro lens. It will focus from far away to close up without any attachments.

OLD ORCHARD BEACH, MAINE

◀A dark background made this dandelion photo more dramatic. Dark backgrounds can be included if you find flowers on the sunlit edge of tree shadows. Another method is to hang a black cloth a few feet behind the subject.

LLANO, TEXAS

▲
Try focusing on a long-stemmed flower on a windy day. As the flower top moves, even a little, it goes in and out of focus. The best time for sharp close-ups is on a windless day or in the still of early morning.

close-up photos will be taken into account by your camera's built-in meter.

The popularity of macro lenses has produced a variety of focal lengths and macro zooms. I consider the 55mm macro the most useful. It does my close-up work and doubles as my normal lens. Longer macros, such as the 105mm, allow close-ups to be made at a greater distance from the subject. It also serves as a short-telephoto portrait lens. If you're really involved in close-up photography, consider a macro zoom lens. The magnification, design, and special effect possibilities of a macro zoom are almost endless.

Any close-up attachment will cause shallow depth of field. To keep your entire subject in focus, use a small aperture (f/11, f/16, or f/32). Another effect of close-up equipment is exaggerated camera movement. Use a tripod and cable release for sharp close-ups.

Some photographers use flash for outdoor close-ups to increase depth of field, even the lighting, and freeze a subject's movement. Special flash set-ups include double flash configurations, one on each side of the camera, and ringlights which are flash tubes curved around the lens barrel. I prefer natural lighting for nontechnical macro work. If the subject is strongly backlit, prop up a white card on the shadowed side for fill light.

The Statue of Liberty, ▶
photographed with a
16mm lens and a red
filter.

6

Special Techniques

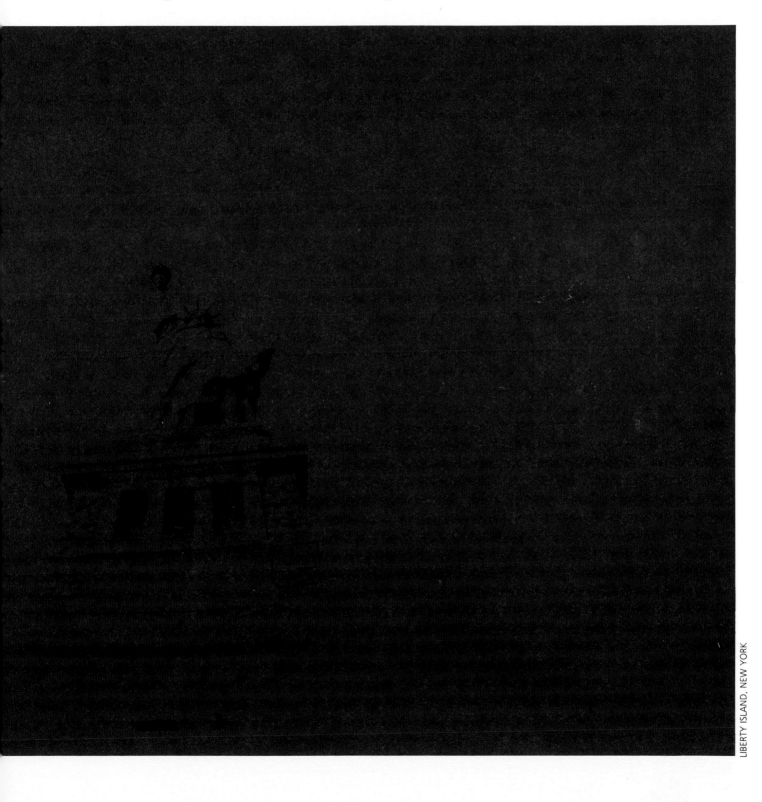

LIBERTY ISLAND, NEW YORK

Lens Attachments:
Color

CARSON NATIONAL FOREST, NEW MEXICO

EL PASO, TEXAS

Split field color filters ▶ are half clear glass and half tinted. The idea is to darken or color one half of the picture, such as the sky. A neutral density split field will darken half the picture without altering the color. Cokin split fields are graduated and will color a large or small part of the picture as they are raised or lowered in the filter holder.

Color spots are colored ▶ filters with a clear center. Thus, your subject can be surrounded with the hue of your choice. Hoya makes red, yellow, and green color spots.

FORT DAVIS, TEXAS

▲
FLD and FLW filters reduce the greenish cast of fluorescent lights on daylight color film. Carry one of these filters when you go on a factory tour or photograph in stores.

MARBLE CANYON, ARIZONA

▲
Bicolor and tricolor filters are two or three different colors in the same filter. The bicolor is a natural for seascapes. Hoya tricolor offers three parallel colors or three pie-shaped colors.

◄**Color polarizing filters** can be rotated to add continuously varied amounts of color to a picture. They come in single and dual colors. A yellow/red color polarizer will make any sunset a show stopper.

PADRE ISLAND, TEXAS

(continued) Lens Attachments:
Color

BRYCE CANYON NATIONAL PARK, UTAH

Single tone filters give ▶
one color to a picture
for a desired effect.
Cokin's pastel filters im-
part a painterly glow to
portraits, and their sepia
filter makes any scene
look like an old tinted
photograph.

▲ WHITE SANDS NATIONAL MONUMENT, NEW MEXICO

**Color multiple image
filters** are bi- or tri-
colored multiple image
filters. Try rotating a
tricolor multi during a
long exposure of some-
thing in motion!

BIG BEND NATIONAL PARK, TEXAS

GLOUCESTER, MASSACHUSETTS

◄ **Diffraction grating filters** create a rainbow effect from light sources in the photograph. The pattern is determined by the filter design. Circular, pinwheel, exploding, and rainbow spears are some unusual filters that I've run into.

80A filters let you use ► daylight color film under tungsten lights without the yellow cast. Use with daylight film illuminated anywhere by tungsten lights: caverns, homes, museums, or sporting events.

◄ **85B filters** convert tungsten-balanced color films for use in daylight, eliminating the blue cast. This filter is especially useful when you're in the middle of a roll of tungsten film and want to take a few shots outside in daylight.

NATURAL BRIDGE CAVERNS, TEXAS

Underwater Photography

The sport of diving has changed. It's for everyone now, whether you snorkel along the surface or strap on scuba gear for deeper explorations. The whole family can dive. Dive shops, clubs, schools, dive parks, camps, and boats are as much a part of a seashore vacation as suntan oil. People travel great distances to dive. Diving *is* the vacation.

Photography and diving go hand in hand. The underwater world is as exotic and photogenic as any foreign land. And it's more than twice as big as all the countries of the world put together. The story of your underwater travels is best told with pictures, and with less specialized equipment than you think.

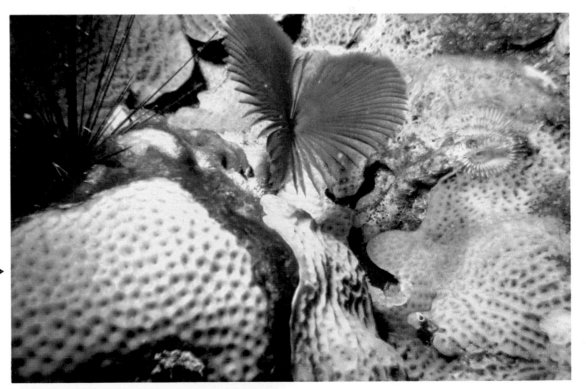

Sharpness and color are ▶ greatly improved by using a flash underwater. Exposure is calculated by figuring flash-to-subject distance, or using an automatic flash. No filtration is needed with flash underwater. (Photo by Eric Nilsen)

More and more people ▶ are traveling underwater as scuba diving gains popularity. It's only natural for divers to bring cameras along for pictures of their travels and the underwater inhabitants they encounter. (Photo by Janet Mendes)

Useful features of the ▶ Nikonos IV are its compact size and that it can be used underwater and on land. A Caribbean or any water-oriented vacation can be photographed solely with a Nikonos—from coral reef to casino!

Cameras Underwater

A camera's insides must remain dry in order to make underwater pictures. There are two roads to accomplishing this: buy a waterproof camera specifically designed for underwater use, or seal your present camera in a watertight underwater housing.

Nikon's "Nikonos" clearly leads the underwater camera market. Underwater explorer Jacques Ives Cousteau originally designed the Nikonos for Nikon. It functions 160 feet underwater and is no larger than a standard 35mm camera. The Nikonos accepts an array of lenses, filters, and close-up attachments. And it functions very well on dry land.

The Nikonos IV burst on the underwater scene as the first automatic underwater rangefinder camera (aperture-priority). It has an oversized viewfinder for "through the mask framing," side handgrips, and an electronically compatible flash.

A Nikonos comes with a 35mm f/2.5 lens. The 35mm lens is a good general-purpose lens for wet or dry shooting, as is the 80mm lens. Wide-angle 15mm and 28mm lenses are available, but are optically corrected for underwater use only.

◄ The Minolta Weathermatic measures 7 × 3 × 1 inches, uses 110 film, floats, and dives to 15 feet. It is the perfect companion for near the surface water sports.

For small-format or occasional underwater photographers, Minolta has come out with a pocket rangefinder camera called the "Weathermatic." The 110 cartridge camera operates up to 15 feet underwater and also floats. It has exposure settings for sunny and cloudy days, focuses as close as 3 feet, and has a built-in flash. This tough little camera weighs only ¾ of a pound. It's perfect for skiing, surfing, swimming, and boating.

Plastic or metal and glass camera housings are bulky but less expensive than the Nikonos. Your regular camera and lens fit into a compatible housing, allowing the advantage of through the lens viewing and metering. Camera settings are made by means of gasket-sealed knobs and levers. Diving magazines are a good source of current manufacturers of underwater housings.

Protective underwater camera bags are new to the underwater scene. These heavy, laminated plastic bags hold a conventional camera in a watertight seal. An inside glove controls the camera's functions. Some bags are large enough to fit a camera and flash. EWA's "Space Suit" will take your camera down to 30 feet for only $60–$80. Available from Pioneer and Co., 216 Haddon Avenue, Westmont, NJ 08108.

(continued) Underwater Photography

Exposures Underwater

Light falls off as it travels underwater. The brightest lighting is within 10 feet of the surface. Morning and late afternoon sun do not penetrate the water much because they reflect off its surface. The strongest natural light underwater is between 10 A.M. and 2 P.M.

Exposure readings should be taken off neutral gray areas, just like on land. A reading of the surface of the water or a sandy bottom will result in underexposure.

Underwater Exposure Guide
Light bottom, midday sun

Film speed	5–10 feet depth	10–20 feet depth
ASA/ISO 64	1/60 sec., f/5.6	1/60 sec., f/4
ASA/ISO 400	1/125 sec., f/11	1/125 sec., f/8

Water turns natural light blue, and it gets bluer the deeper you go. Most divers use a CC30 red filter to correct the blue cast down to 30 feet. Beyond this depth, there isn't enough of the other colors to photograph them without auxiliary lighting.

Flash Underwater

Flash brings out the vibrant colors existing underwater. It is the diver-photographer's best tool for deep water close-ups, freezing motion underwater, and obtaining rich colors in murky water.

The "state of the art" underwater flash is automatic—it shuts off when the right amount of light has reached the subject. Better units also have thyristor circuitry, which means more flashes per battery. Underwater flash units can be used on land also.

Flash works well up to about 10 feet underwater. The major problem with using flash underwater is that tiny particles in the water will reflect the flash back—a phenomenon known as "backscatter." The result is a cloudy white picture. Moving the flash off camera minimizes backscatter; this is the reason for such long arms on underwater flash units.

◀ Not all underwater photography is of fish in the briny deep. Current trends in artistic photography include figure studies in swimming pools. (Photo by Steven Bridges)

ROCKY NECK, MASSACHUSETTS

Seeing Underwater

Little particles suspended in the water cut down on visibility, sometimes to 200 feet. Whatever the visibility is, a good rule of thumb is never shoot anything more than ¼ of the distance you can see. If you do, expect subdued colors, low contrast, and poor definition.

Visibility barriers can be overcome by getting close to your subject. Close-ups come out better underwater because there is less substance for the image to travel through. Wide-angle lenses exhibit more clarity underwater than do telephotos because one is forced to get close to the subject in order to fill the frame.

Underwater Photo Tips

- Visit area dive shops for advice on good spots, visibility, and interesting sea life.

- Don't jump into the water with loose camera equipment; have it lowered on a safety line.

- Dive and photograph with a buddy.

- Steady your camera against your mask and hold your breath for sharper pictures.

- Be patient. The fish will come to you. Bait may help make friends.

- Rinse and dry your underwater camera before changing film or lenses.

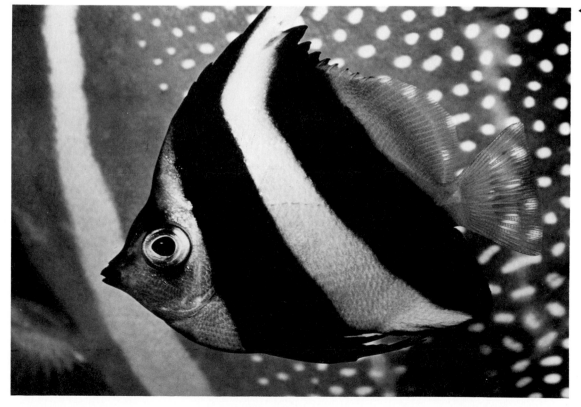

◄ Underwater close-up photos exhibit more clarity than distant shots. This is because there are fewer particles over a short distance to cloud the picture. (Photo by Janet Mendes)

Infrared
Photography

Few of us would want to record our entire vacation on infrared film because it sees things so differently. It is extra sensitive to the infrared wavelengths, which are invisible to the eye. An infrared photograph has an altered tonality which is dreamlike and strangely beautiful. Expose a roll or two on your travels, and expect the unexpected!

Infrared film comes in black-and-white and color. The most popular black-and-white combination is Kodak High Speed Infrared Film and a medium red filter (#25A). The red filter screens most of the conventional light enhancing the infrared effect. Tones will appear fairly normal with a few striking exceptions: leaves and all other chlorophyll vegetation will be snow-white, water will be black, and haze vanishes.

Kodak Ektachrome Infrared Film should be called "Infrared Unpredictable Film." It records infrared reflective subjects as red; the other tones depend on the filter being used. A yellow filter (#12 or #15) used outdoors with color infrared film yields dark blue skies and red vegetation. An orange filter (#21) gives colorful and unpredictable results.

Infrared Techniques

Follow the instructions packed in the film box. As a standard guide, set your film speed on ASA/ISO 80 for black-and-white infrared and 200 for color infrared. Bracket your exposures +1 and −1 to insure an acceptable exposure.

Color infrared pictures are focused in the normal manner. But critical focusing for black-and-white infrared film with red filtration requires that the subject distance be set manually at the red mark on the lens barrel. Doing so will compensate for the slightly different plane on which infrared wavelengths focus.

Load and unload black-and-white infrared film in total darkness. Do it at night in a darkened room with the drapes drawn. Retreat into the closet if necessary. Color infrared film can be handled in subdued light. Keep both infrared films in the refrigerator before and after use. And because of the film's instability, process it as soon as possible.

Water that is reflecting a ▶ blue sky will be rendered dark with infrared film. Any plants on the water containing chlorophyll will be a contrasting white.

BOSTON, MASSACHUSETTS

◄ The cow became white and almost glowing from the effects of a #25A red filter and infrared film. Much of the conventional light coming into this scene was screened, and the remaining infrared light highlighted the clouds and made the leaves white. (Photo by Russell Hart)

NOVA SCOTIA, CANADA

◄ Eerie results are typical of infrared film. Here, the laundry and white trim of the house contrast against a black sky. A good starting point is to expose Kodak High Speed Infrared Film at 1/250 sec. at f/8 with a #25A red filter in full daylight. (Photo by Russell Hart)

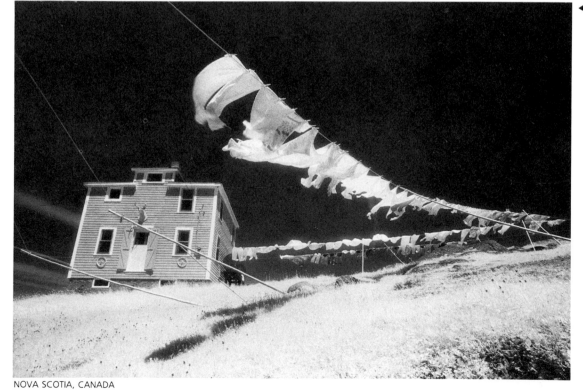

NOVA SCOTIA, CANADA

Special Effects Filters

◄ **Soft focus filters** are used to soften the detail and shadow the edges in portraits, landscapes, and still lifes. They are available in degrees of softness. Some are sharper in the center.

Fog filters put a thin, white veil over the picture. Any scene can be "mistified" with fog effect filters, which come in different densities. Cokin produces a graduated fog filter that makes the distance appear foggy. ▼

NATCHEZ-TRACE PARKWAY, MISSISSIPPI

◄ **Vignetting filters** have a clear center and soft edges. Commonly used to make a face stand out, vignetting filters can emphasize any subject by making it the only sharp object in the picture.

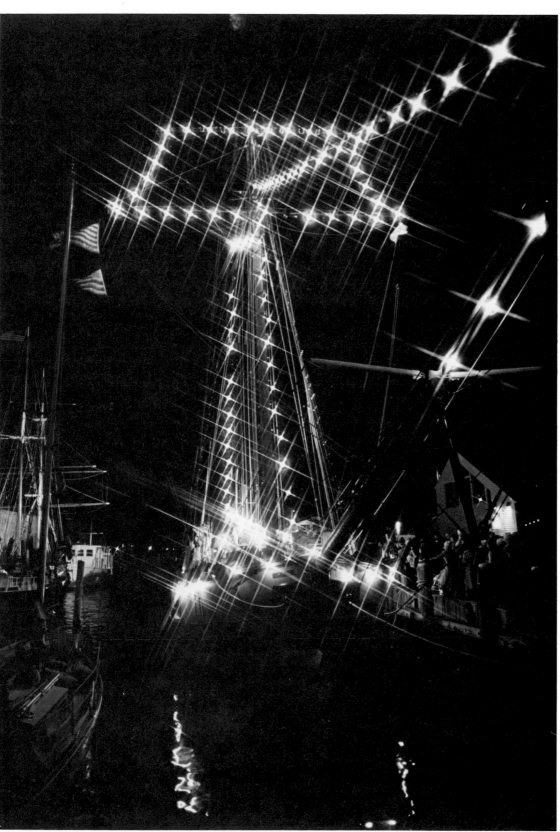

NEWPORT, RHODE ISLAND

◀**Cross screen attachments** will make stars out of point light sources, such as street lights at night or sun on the water. The type of cross screen will determine how many points the stars will have. Fun to use at night.

(continued) **Special Effects Filters**

BIG LAKE, TEXAS

Multiple image attachments repeat the central image. Triangular, circular, parallel, and assorted repetitions of the image can be had. Most types will rotate the images as the attachment is turned. ▶

Split field close-up filters are half close-up lens and half clear glass. They enable you to focus on a very near object and a far object at the same time. Works well with landscapes. Take care to hide the focus line in the picture. ▶

BIG BEND NATIONAL PARK, TEXAS

DENVER, COLORADO

▲
Linear motion attachments make a streak or blur around subjects in the center of the frame. Available from Hoya, these filters will make any action photo seem more kinetic.

◀ **Masks** are used to black out the area around the main subject. Hearts, keyholes, and snowflakes are just some of the masks you can buy or make. The sharpness of the mask outline will decrease as the lens aperture is opened.

There is much pleasure ▶
to be had in sharing
your photographs with
others. If you've gone
to some effort to get
good travel pictures, it's
certainly worthwhile to
show them in a lively
and enjoyable way.

Showing Your Travel Pictures

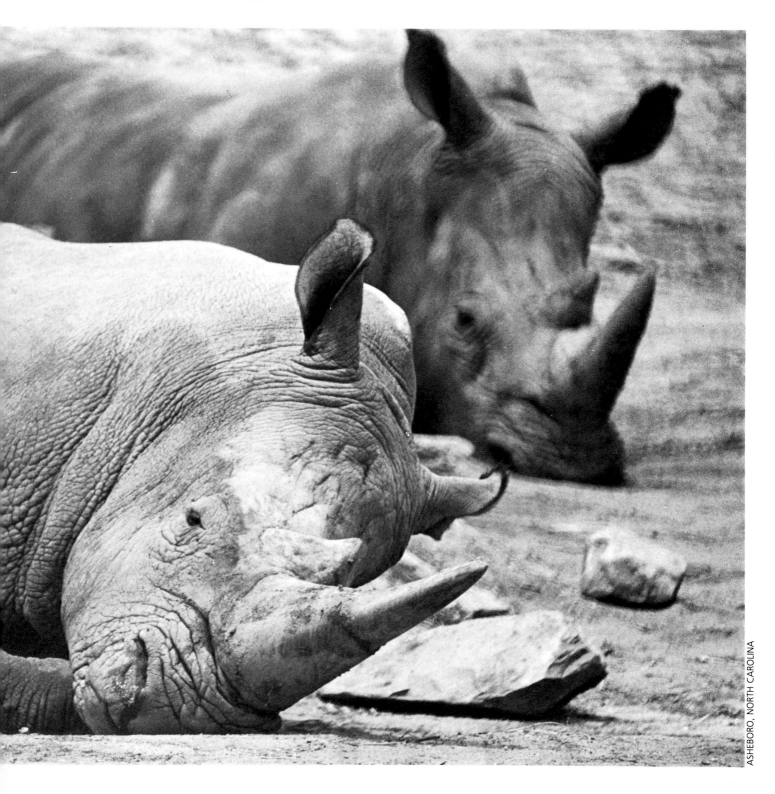

Trip Albums

The most common vehicle for sharing pictures with others is the photo album. The economical 3×5 inch prints that come back with the processed film can be utilized; no fancy equipment is necessary, the room need not be darkened, and viewing is as casual as turning pages in a story book.

Today's photo album is sometimes called a "visual display book." With just a little extra effort, you can turn the old photo album into something exciting.

Edit: Select the best for your album. Eliminate duplicate scenes. Drop the worst of your "just missed" and technical oversights. Look for photos that tell the story, photos that you find interesting. Choose close-ups, distant scenes, and anything that describes what you felt like. Highlight personalities, the faces of your fellow gadabouts and of folks along the way.

Think Spreads: Your audience is looking at an open book—taking in two pages at once. Let the two facing pages tell the same story. For example, an East Coast trip album might include a weekend jaunt to New York City. Make a two-page spread of the Big Apple in your album. The left-hand page might include street scenes and the Statue of Liberty. On the right, put the Bronx Zoo pictures and dinner at Aunt Ginny's. A European tour album might be broken down into spreads of your favorite cities, regions, and side trips.

Spacing: Pictures look better when they're not all crowded together. Purposely leaving blank areas around your prints lets the viewer concentrate on the individual images and not the jumble.

Page design is an art of feeling and function. Move the prints around on the page until they look good. Some shots will relate to others by content or color, so let them be neighbors. Others will not sit well together visually.

Look at some well-designed magazine layouts for ideas. You'll see sequences, overlapping pictures, and photos that extend to the edges of the page (called a "bleed"). Be creative with your trip album.

Sizes: Another variable you can play with in page design is print size. The best images usually deserve to be enlarged to 5×7 or 8×10 inch prints. But don't overlook blowing up a shot on the merits of pattern (a close-up) or pure color. Pictures can be surprising when they're big.

Also, you can crop prints to liven up your layout. A skyscraper photo might be cut down to a long, skinny print. Likewise, a long train picture could be cropped horizontally, or even cut into sections and extended across two pages if it's large enough. When starting your album decide if you want white borders around the prints and if they should have a matte or glossy finish.

Mix Media: For a truly fascinating trip album, include a few cultural souvenirs picked up along the way. Paper money, opera tickets, menu selections, matchbook covers, beer coasters, wine bottle labels, parking tickets, and airport luggage tags are just a few items that can make your album a more personal and conceptual book.

The Album: Your local stationery and camera stores sell albums. Pastedown photo corner styles have been supplemented by magnetic page albums. The plastic cover sheets in these albums cling to the paper pages to hold down the pictures. Photos can be repositioned or replaced at any time.

Another type of album is the three-ring binder with clear plastic pages. The 8½ × 11 inch pages have various sized and positioned pockets to hold your prints. Your layout will be determined by the arrangement of the pockets. A variety of styles are available; one plastic product manufacturer, 20th Century Plastics, offers at least a dozen plastic page configurations. Write for a free catalog: 20th Century Plastics, Inc, 3628 Crenshaw Blvd., Los Angeles, CA 90016.

Photo Cubes

Photo cubes are made of clear plastic and have a cardboard insert which holds five photos in place. The pictures face out in five different directions.

To make your picture cubes something special, buy two, three, or more of them. Have prints made of brightly colored subjects that are relatively large within the frame. Or try using subjects that would be enhanced by horizontal sectioning: trains, skylines, reclining figures, and landscapes. Have the prints you decide to use made without borders.

Think ahead to how two or three cubes will look side by side. Carefully done, your cubes become a match-puzzle, or contemporary coffee table display.

A Manhattan skyline picture was made into 11 × 14 inch prints, cut up, and inserted into the photo cubes. Different cities could be displayed this way, one on each side of the cubes.

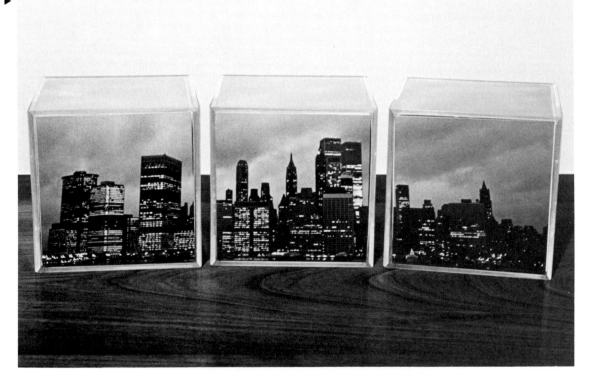

Photo Cards

Your favorite travel pictures can be sent to your friends as holiday cards and postcards. Such personal touches are warmly received and indicate the pride you have in the photographic craft. In fact, many professional photographers endear themselves to clients with photo cards.

The Eastman Kodak Company will print your color photograph (from a slide or negative) onto a greeting card. They offer a selection of sizes and sentiments. You can choose to have no message printed on the card and use it for all occasions. Ask your photo dealer for details.

Another easy way to make color prints into mailable postcards is to apply preprinted self-adhesive postcard backings. Your print must match or be trimmed to the backing size, usually 3½ × 5 inches.

If you have access to a home darkroom, other avenues of photo card production are opened. Kodak manufactures 3½ × 5 inch black-and-white photographic paper with a preprinted postcard form on the back. This product will allow you to inexpensively make photo postcards as fast as you can expose and process them.

Also available for the home darkroom enthusiast are photo greeting card and calendar masks. To print one: 1) Tape the mask to the underside of your enlarging easel blades; 2) Focus your negative in the clear area of the mask; 3) Mark the easel blades with tape or grease pencil where the

NEW HAMPSHIRE CIRCA 1900

◄If you're lucky enough to locate an old negative or glass plate, you can make your own antique postcards. This one was contact printed from a 4 × 5 inch glass plate negative.

clear area stops and the calendar numbers start so you can cover it up later; 4) Insert enlarging paper underneath mask; 5) Expose your negative through clear area; 6) Cover clear area with cardboard and flash the sentiment or calendar side with a flashlight. 7) Develop normally.

Porter's Camera Store, a mail order supply firm, sells an impressive array of photo card items. They even have reward masks, recognition masks, and century old calendar masks. Write for their free catalog: Porter's Camera Store, Inc., Box 628, Cedar Falls, IA 50613.

One final postcard-making technique is to use a postcard rubber stamp. Stamp the back of any postcard size photograph and you have an instant postcard. Bear in mind that the United States Postal Service will not deliver postcards smaller than 3½ × 5 inches.

Framing Your Photos

Your better photographs should be promoted from the photo album to the wall. Hang pictures that you personally like, and that contribute to the overall decor. Like your furnishings and the clothes you wear, a framed photograph is an expression of who you are.

Keep these criteria in mind when selecting photos for hanging. First of all, do you like it? Can it be called interesting because of its content, or does it feature strong graphics? Sometimes photographs will look better on the wall if they are grouped, sectioned, or put in a sequence. Where a photo is hung in a room also influences its visual impact.

Matting a photograph is ▶ usually the first step in the framing process. Mat cutters are available in art supply stores if you want to cut them yourself, and some frames come with precut mats in standard sizes.

About Frames

Mat: The photograph is sandwiched between two pieces of quality cardboard, one of which is a window around the photo. This top part of the mat comes in many colors, but white, gray, and black are most commonly used. A mat's function is to keep the photograph flat and prevent it from sticking to the glass when it's framed.

Block Mount: The photo is flush mounted (to the very edge) on a piece of cardboard, foam board, plastic, or wood. This "frameless frame" requires no glass. Block mounts that stick out from the wall give a contemporary look. A simple strip frame can be fastened around the edges of a block-mounted print.

Glass Frames: A matted photograph is held between a heavy cardboard backing and a piece of glass. Clips or corner brackets hold the entire assembly together. Twine pulls the clips tight behind the photo and serves as the hanging wire. Glass frames impart a clean, contemporary look, are inexpensive, and photos can easily be changed.

Metal Bracket Frames: Sold in easily assembled kits, metal frames are inexpensive and lend themselves to the framing of prints, drawings, and photographs. Silver, gold, and pewter are among the metallic colors offered.

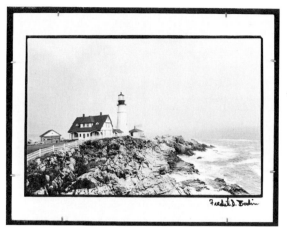

Prints can be framed in ▶
Plexi-boxes in a few sec-
onds. They come in
standard sizes from
4 × 5 to 16 × 20 inches.

◀ Gallery clips hold a mat-
ted photograph be-
tween the glass and a
cardboard backing.
Glass frames are inex-
pensive and easy to
assemble.

Plexi-box Frames: An inch-deep
Plexiglas box frames the matted pho-
tograph. A cardboard-box insert
presses the photo to the face of the
Plexiglas box. For an unusual three-
dimensional effect, try extending the
photograph around the sides of the
box frame.

Wooden Frames: Traditional
wooden frames are available in
hundreds of colors and shapes. Glass
or Plexiglas can be used as facing.
You can frame your photographs ex-
pertly with a little help from the staff
at "frame it yourself" shops. Or if
you're really adventurous, you can
hunt up frames for as little as 25 cents
in antique shops.

◀ Borderless prints look
best on a block mount
frame. Either have the
photo printed without
borders or trim them
with a razor blade.

◀ Simple wooden frames
work well because they
do not divert attention
from the photo. If re-
flections from a nearby
window are a problem,
use glare-free glass.

Black-and-white prints ▶
are complemented by
silver metal bracket
frames. The frames
also fit well with "high
tech" metal and glass
furniture.

Hanging Your Photos

Singles: A single photograph must have the visual strength to stand on its own. It must also be large enough to compete with the furnishings and colors in the room.

To place a single photograph for hanging, you need to balance it with the available wall space and the visual weight of nearby doors, windows, and furniture. The best way to do this is to enlist a friend and try different locations. Stand back and eye the photograph. When it looks right—hang it!

Groups: Since viewers will take in the entire group and then concentrate on specific photos, this is your chance to make the images relate. Try to achieve a group theme in subject matter or color. Although the individual pictures may be small, the visual weight of the group should be taken into account when balancing it with other objects in the room.

Tiltless Picture Hanging

1. Predrill holes for screw eyes on inside edges of frame, about ¼ of the way down from the top of the frame.

2. Screw in eyes, using pliers to tighten them if necessary.

3. Wind picture hanging wire (not string or fishing line, please) around screw eyes. Leave enough play in the wire so that it will reach near the top of the frame.

4. Hang the picture on two hooks, screws, or nails, each spaced about ⅓ in from the sides of the frame.

Creative Framing

Multiple Image Mat: A multiple image mat has two or more separate windows. The photographs in this kind of mat need to relate to each other. A sectioned photograph (see below) or sequence will work well here. The mat windows can be of different sizes. Locate them anywhere on the mat where they look good.

Sectioned Image: To discover whether a photograph can be tastefully sectioned, cut apart a small print of it. Try not to cut through important parts of the picture, if you can help it. Sections can be of increasing or decreasing width. Don't overlook the possibilities of both horizontal and vertical arrangements. Sectioned images look best when block mounted.

Enlarged Contact: An entire contact sheet or a section of one is enlarged and hung in a contemporary frame. Incorporating a glimpse of the process that most people never see is exciting. It also implies professionalism and your involvement with the art.

Choose a sequence or nonrepetitive images. They should be related by subject matter. It would be advantageous to have all horizontal or all vertical images in an enlarged contact. You might even consider shooting a roll just for this purpose.

Black-and-white or color negative film can be used for enlarged contacts. Most custom photo labs are equipped to make 16×20 or 20×24 inch contact enlargements. A plain glass or Plexi-box frame will enhance your enlarged contact.

The best poses from a portrait session, an action sequence, or slight variations of the same scene are suitable for a multiple image mat.
▼

Illusory Image: Here a photo is used to fool the eye into thinking it's the real thing. The three-dimensional nature and unusual placement makes the viewer do a visual double take. A good example is a landscape photograph hung in an artificial window frame. Blinds or curtains—either real or photographic—may be added at your discretion.

Everyday objects, such as fruit, eating utensils, or umbrellas, can be displayed as illusory images. One avant-garde artist caused a great uproar at a large museum by pasting up lifelike photographs of light switches and wall sockets.

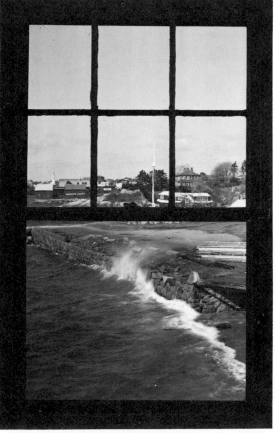

◄This picture was taken through a window. When enlarged to poster size and hung on a windowless wall, it functions as an effective illusory image.

▲
One or more relating frames of the contact sheet are enlarged, including the outside edges of the film. En-

larged contact sheets can be made from black-and-white negatives, color slide film, and color print film.

▲
Bryce Canyon, because of its spires and pinnacles, fits well into the sectioned image format.

A single spire could have been sectioned vertically.

Unusual Mediums

Photo Linen

A special photosensitive cloth is available which allows you to print black-and-white images on it. Nothing more than an ordinary black-and-white darkroom is required. After realizing the potential of photo linen, you may wish to add a sewing machine to your equipment inventory.

To execute the designs you have in mind, it may be worthwile to go out and shoot just the right kind of picture. Simple structured images and high contrast work well. Although the photo linen process is black-and-white, the images can be colored.

Photo-pillows, quilts, and wall hangings are some of the applications of photo linen. They can be substituted into any pattern where a printed fabric would normally be used. (Photo-pillow by Tia Cross)
▼

Cushions: Simply print onto the right size photo linen, sew, and stuff with polyester batting. Flowers, leaves, shells, and landscapes are just a few of the many possibilities for photo-linen cushions.

Formed Cushions: This is a cushion cut to the shape of the object that the photograph represents. I recommend planning a pattern first, then printing on a photo linen. The only limit on subject matter is your imagination.

Wall Hangings: A wooden dowel on the top and bottom will suffice to hold your hanging. A serene or delicate nature scene will impart an oriental flavor. If you prefer modern decor and images, substitute an abstract or city scene, and hang it on Plexiglas rods.

Window Shades: Yellowed old shades can be replaced with your own images printed on photo linen. Consider the option of dying the entire shade after the image is fixed.

Divider Screens: Stretch your photo linen print across an antique screen frame, or build one yourself.

Liquid Photo Emulsion

Almost any material can be coated with brush-on or spray-on photo emulsion. The object becomes photosensitive and can be used as a printing surface. Put the object under the enlarger and expose it. Then process it in black-and-white chemistry. Some coated objects are better processed by brushing or sponging on the chemicals.

The list of materials that can be used for liquid photo emulsion treatment is long. Wood, metal, glass, Plexiglas, shells, eggs, paper, and cloth will get you started.

Objects treated with photo emulsion can be useful as well as decorative; bricks become bookends, tiles become photo splashboards, thin Plexiglas or mirrors can be hung as mobiles.

Liquid photo emulsion ▶ was applied to a brick and the image of an old building was printed on it. Some felt was then glued to the bottom of the brick. It can be used as a decoration, a paperweight, or a bookend.

Slide Shows

The most dramatic theater for your travel photography is the slide show. Here is where your pictures are in their biggest most colorful form, and in command of your audience's attention. Add the appropriate music or sound effects. Paint the screen with slides of rhythm, movement, and color. You can create your own audiovisual production with one slide projector and your home stereo.

Choose a Theme

Make it easy on your viewers and stick to one story. A show that jumps around is confusing, if not tiring. The *vacation diary* takes the audience from the airport to your destination. It presents the details you saw along the way, how you felt, and what interested you most. Show photographs of the events, people, and places you encountered along the way. Include in-depth interludes, such as a visit to a world-famous restaurant: the place, the meal itself, waiters, close-ups of the menu or placemats, or even the elegant powder room!

A *specific theme* focuses on a country, a region, or a city. Instead of arranging your slides chronologically, sequence them according to topic or locale. A show on Cleveland, Ohio, could move from the glass and steel downtown plaza to the chic renovated industrial "Flats," and maybe wind up at dusk on the rolling lawns of Blossom with the Cleveland Symphony— the source of your soundtrack.

Edit

All the boxes and boxes of slides need to be edited down to about fifty to eighty images. Eliminate overly dark and light slides, posing mistakes, boring and repetitive shots, and technical foul-ups. Make a pile of sure shots and a pile of alternates.

At this point you'll wish you had a light table. A 2 × 2 foot light table will let you set up, sequence, and view an eighty-slide show at a glance.

Sequencing

A good slide show has a beginning, a middle, and an end. Start with a slide that identifies your theme. It could be an easily recognizable cultural detail, a sign, your travel visa, or a homemade title slide.

The body of your slide show develops the theme. In it are your most important travel pictures. Diversify the kind of photos in sequence by mixing in close-ups, silhouettes, special effects, and the use of different lenses. For smooth transitions link each image to the next by relating color, angle, or subject.

Close your show on a pleasant note; a child's portrait, a field of flowers, a sunset, or a humorous picture. And don't forget to take a bow yourself with a shot of the photographer in action. Turn on the room lights while the last slide is on the screen to spare snow-blinding your audience with a white screen.

Making a Light Table

1. Find a small rectangular table at a yard sale or used furniture shop. It should be large enough to sit at.

2. Visit a commercial plastics manufacturer with a scrap bin. Buy a piece of ¼ to ½ inch translucent white Plexiglas large enough to almost cover your table.

3. Cut a hole in your editing table to fit the Plexiglas. Be careful not to cut through the table legs or supporting crosspieces. If necessary, cut the Plexiglas to fit with a Plexiglas scoring blade.

4. Attach a wooden lip under the table to hold up the Plexiglas.

5. Wire or build a carriage under the Plexiglas to hold a fluorescent light. Two small straight tubes or a circular one should do the job. Don't overlook the new screw-in socket fluorescent lights. Experiment to find the proper distance between light source and Plexiglas for a bright enough viewing surface and more or less even illumination.

6. A deluxe addition to your light table is a thick piece of clear glass set in over the Plexiglas (make it flush with the tabletop) or covering the entire table surface. The glass will prevent scratching the Plexiglas and make cleaning easier.

7. A professional touch to your light table are color correct fluorescent tubes. With this illumination, you can more accurately judge if a slide's color is off, and what corrective filtration is needed. A photographer who is selling color for publication should have a color correct editing table.

◄ A light table and magnifying loupe are the best tools for inspecting and editing your slides, short of projecting them. You can rig up an inexpensive light table at home or get a fancy one if you'll be editing a lot of slides. This table, which comes with a hinged dust cover, is available from the Picture Guild, Box 331, Jamaica Plain, MA 02130.

(continued) **Slide Shows**

The Setup

A square projection screen works best because it will accommodate both horizontal and vertical slides. Standing and hanging screens are available from several manufacturers and come in many sizes. Alternatives to conventional screens are flat white walls, white cardboard panels, and your TV screen (in off position). With all screens, the darker the room, the brighter the projected image.

When choosing a slide projector, first analyze your needs. How big is your intended projection room? Do you need optional autofocus, remote control, timer, or full accessory outlets? And, if you'll be showing your slides on other people's projectors, buy one with compatible trays.

Set the projector back far enough to fill the screen. If the room is very small, optional wide image lenses are available for most projectors. Mount the projector on a rigid stand and try to keep it level. If you angle the projector, distortion will cause the top or bottom of your slide to be out of focus.

Using Sound

Some photographers shy away from having sound with their slide shows because they anticipate a complex and expensive process. Not so. Merely playing a Reggae record during your Caribbean slide show will captivate an audience. Manually advance the show as you talk, let the images meet the rhythm of a fast song, and why not serve the local food and drink?

When traveling, listen for popular local music. Visit a record store and buy something you like with the cultural flavor. It would be a useful souvenir and soundtrack.

Today's pocket stereo cassette recorders are smaller than a camera. You can make instant quality record- ings on your travels anywhere you think sound will add to what you shoot; a rain forest at dawn, the babbling brook, a crowded outdoor marketplace, foreign radio, an entertainment hotspot, or seagulls, foghorns, and waves crashing.

It's easy to prepare a customized slide tape if you have a tape deck and record turntable at home. First, arrange the slides in sequence the way you want them. Then record onto a blank tape, in stereo or mono, songs and/or sounds that you feel follow the pace of the slides. Whether you're taping off your turntable or pocket tape recorder, the sound is always better when recorded from the built-in jacks rather than the microphones.

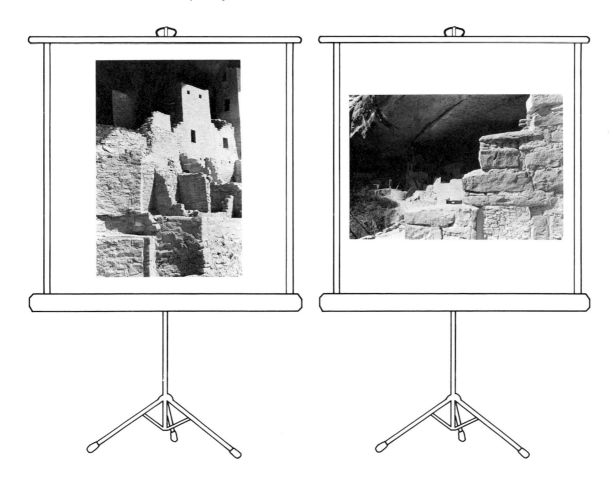

Storing Your Photographs

Negatives

All your black-and-white and color negatives should be rounded up and stored safely. The longer you put it off, the larger the job will be.

First get a large, strong, tight container for central negative storage. Two-drawer filing cabinets are perfect and you can buy them in colors at discount stores for under $40.

Such file cabinets armor your negatives against kicks, spills, light, and dust. And if all negatives are stored here, loss is minimized. One photographer I know went crazy looking for some negatives she kept in odd places around the house. She's still not sure if they went into the wood stove or not.

Once a base camp for your negatives has been established, slip each roll (usually strips of five or six) into a glassine envelope or acetate negative page. I prefer glassines for economy and protection. Whichever system you prefer, the envelope should be coded to correlate it with its corresponding contact sheets and prints.

Date coding works for me. When a roll is put into storage, I put the nu-

merical date on it: 072883 was filed on July 28, 1983. If more than one roll was shot, just add -1, -2, -3, etc., after the date code. Remember to write the filing number on the back of corresponding contact sheets and prints.

The coded glassines should be chronologically ordered, put into a cardboard or plastic box, and then into the file drawer. Or, it you prefer acetate pages, they can be chronologically paged in a three-ring binder, boxed, and kept in the file cabinet.

Slides

It's tedious to rifle through all those little boxes when you're looking for a slide. Numbering, captioning, and stacking the boxes in order helps somewhat, but there's a quicker and safer way to file your slides.

Vinyl slide pages solve the slide storage problem for many of us. Stock photo agencies, the pros, students, libraries, and hobbyists use these pages for quick reference and easy editing. They also guard against scratches, fingerprints, and dust.

Whether of clear or frosted backing, the standard page holds twenty slides. Side loading pockets are preferred to the top loading ones because slides are less apt to fall out.

The pages themselves fit into three-ring binders or slip into hanging file folders in a file cabinet. If you anticipate having more than a few hundred slide pages to store and will need ac-

A roll of negatives is cut ▶ into strips of six. Each strip is put into a glassine sleeve. All sleeves are put into one large envelope. The envelope is coded for date identification: 072883 (July 28th, 1983). The contact sheet and prints from this roll are coded with this number.

cess to them frequently, pass on the ring binders and set up a hanging file system. You'll save time and money.

Buying single slide pages may be expensive (30 to 50 cents each). See if your photo supply store can pass a quantity discount on to you with a box of 100 pages (20 to 30 cents each). If not, order directly from the manufacturer: 20th Century Plastics, Inc., 3628 Crenshaw Blvd., Los Angeles, CA 90016. (Free catalog.)

Prints

All prints, black-and-white and especially color, should be stored away from light, heat, and humidity. Your best small prints can be stored in the photo album, out of direct sunlight. And it's OK to keep extra prints that won't go into your album in the processor's envelope or in a box. Just as long as you can find a print when you want to.

But when you start collecting a sizable number of 8 × 10 inch prints (which will happen if you set up a home darkroom), envelopes and boxes won't cut it. Again, hanging file folders provide the safest, cheapest, and most easily retrievable storage. Prints, like slides, should be filed according to subject or location. As you explore different parts of the globe, new files can be created. Or, if one geographic file gets too fat after your third visit to Ireland, break it down into counties, cities, or regions.

◄When you store your slides in sheets, it's easy to locate the picture you want. And as your slide collection grows, you may want to group similar subjects or geographic areas. Hanging file folders are one way to separate and store the groups of slide pages. This is how stock picture agencies file their images.

◄Like slides, when your print collection outgrows the boxes and albums, it can be logically separated into categories and stored in hanging file folders in a file cabinet.

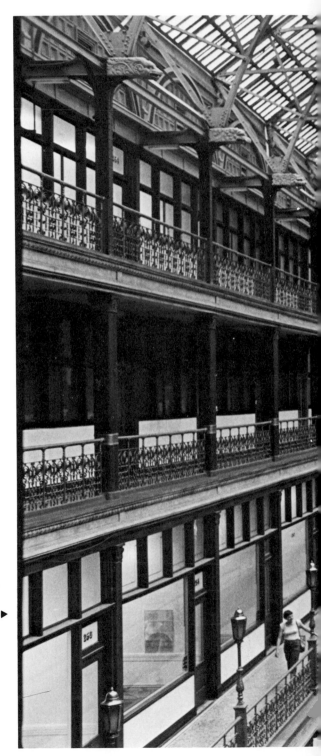

Travel pictures can earn ▶ money for the photographer with a good eye and knowledge of photo markets. There are hundreds of outlets for all kinds of photography. This photo, for example, has appeared in business, mathematics, and social science books.

112

Selling Your Travel Pictures

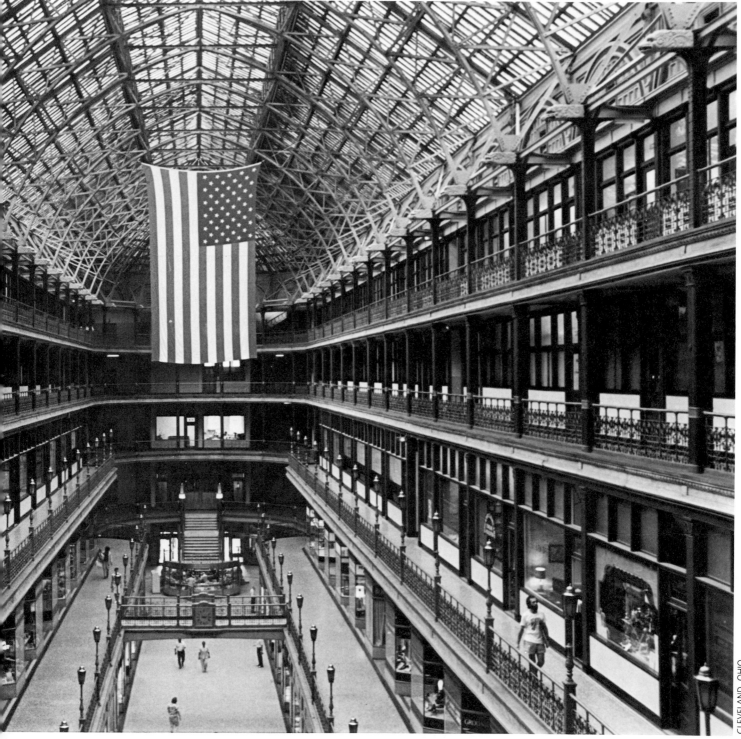

CLEVELAND, OHIO

A Market Perspective

Getting started in the selling of photographs is similar to the first time you looked under the hood of a car: there's a lot of stuff down in there, and maybe the messing around with it is best left to a trained mechanic. But why not loosen that wing nut and see if the air filter is dirty? Or check the oil—and then change it! Step by step, you can learn to do anything, *if you want to*.

Not all readers of *How to Get the Best Travel Photographs* want to sell their pictures, and not all can—right now, anyway. And reading this chapter probably won't land you an assignment with *National Geographic* this week. But it may be the first step down the road to professional travel photography. All the steps and all the markets are mapped out in my book

The Freelance Photographer's Handbook. If you can't find it locally, write to the publisher: Curtin & London, Inc., 6 Vernon Street, Somerville, MA 02145.

Let's look at some facts about the travel photography market. First, almost all of it is freelance. This means you can do it part time or full time, and your images can compete in any arena. Secondly, there really is work out there. Too many photographers can't see beyond the glossy travel magazines. There's so much more. And third, to become a so-called pro what you must do is work very hard and produce good, *salable* pictures. For some, it could take five or ten years of hard work to sell pictures easily. And for you—there's only one way to find out.

An assignment is not al- ▶ ways necessary to sell travel photographs. Originally shot as a lens test, I thought this photo of the sand dunes was too abstract to be marketable. It has already passed the thousand dollar mark in sales.

TRURO, MASSACHUSETTS

Steps to Publication

1. LOCATE publications in your field of interest. Look for them at news-stands, in the library, and in the yellow pages under "Publishers." Study photo market resource books, such as *Photographer's Market*. These books list publications of all types with basic descriptions, photo needs, rates, and who to contact.

2. RESEARCH publications of interest to you by obtaining a sample copy, studying back issues and photo market resource data, and requesting photographer's guidelines from the publication, if available.

3. EVALUATE your qualifications for approaching the publication. Do your pictures share a similar techni-cal quality with those actually pub-lished? Are you prepared with the proper equipment and lighting techniques? Do you have relevant subject matter in your portfolio? It is worthwhile to take as long as necessary to tune your work to a particular market.

4. PURSUE your market with the in-tent to sell photographs. Shoot practice assignments, call, go on in-terviews, send self-promotions, keep in touch. If things aren't clicking, find out why and take steps to correct them.

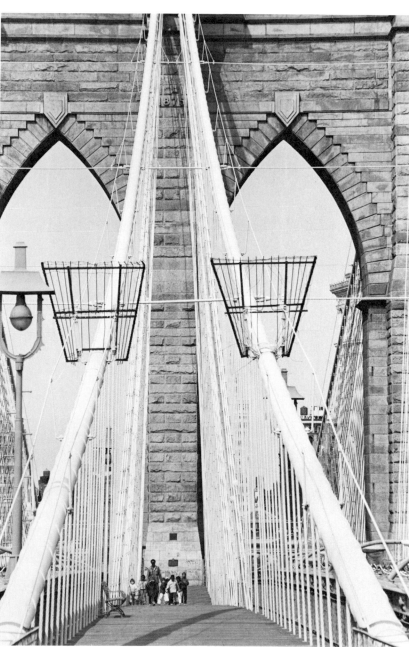

BROOKLYN, NEW YORK

▲
Better images result when you shoot some-thing that interests you. In other words, if it moves you, shoot it, even if it's the Brooklyn Bridge!

Magazines

The Market

The steady expansion of the tourism industry has been accompanied by the growth of travel magazines. Other kinds of magazines use travel-related stories to liven up their features, or to give an exotic angle to a story. There are many different types of magazines that use travel photography.

General Interest: Not devoted exclusively to travel, these magazines appeal to large audiences by covering a wide range of topics. In addition to news reporting, medicine, and celebrities, look for features on exotic destinations, unique trips, and cultural profile stories *(National Geographic)*. Many magazines and Sunday newspapers run regular travel sections.

Special Interest: Within this group are magazines targeted at the traveler. *Adventure/Travel* and *The Happy Wanderer* are of special interest to the traveler. Other special interest maga-

zines, such as *Backpacking, Bon Appetit,* and *Diver,* use travel-related stories to spice up their contents.

Regional: Geographic, state, and city regions are covered by magazines such as *Yankee, Texas,* and *New York.* Some regional magazines offer a topical mix: dining, entertainment, issues, personalities, and local travel ideas. Still other regionals deal exclusively with travel, some reading like directories of things to do, eat, visit, and where to stay.

Corporate: Many companies publish magazines for their employees, customers, stockholders, and business friends. Travel features are used frequently, and not necessarily with a product tie-in. Traveler service magazines are published by hotel chains, bus and train lines, car rental agencies, and airlines. In-flight airline magazines in particular have taken off in the last few years, and have become a lucrative market for photographers.

Club: People subscribing to service associations and certain credit cards receive club publications. *Travel and Leisure,* the American Express magazine, has become one of the best respected and highest paying travel magazines around.

Breaking In

After you've located a magazine of interest with photos within your techni-

One of the benefits of travel photography is finding those special tucked-away places. This Catskill inn, photographed for a tourist guidebook, was as pleasant to stay at as it looks.
▼

CATSKILL MOUNTAINS, NEW YORK

cal grasp, it's time to prepare the sell. Do a complete research by studying back issues, checking out the magazine's competitors (other possible clients), and calling or writing for photographer's guidelines. If no printed guidelines are available, ask on the phone for the magazine's preferred interview procedure for photographers.

Next, assemble a *tailored* portfolio. A portfolio composed of relevant photographs, the kind and quality the magazine might actually use, is crucial to the winning of a client. Give yourself a competitive advantage and go shooting specifically for a tailored portfolio.

Based on your research of the magazine's content, list a few story ideas that you'd be interested in shooting. This is how many photographers generate their own assignments. But even more important, it shows the editor that you are sincerely interested in the magazine.

Now you're ready to call to schedule the interview or mail in your work. Always call for an appointment. Editors consider it rude for photographers to just drop in. And always call even if you plan to mail your work. A phone call makes you a person to a distant editor—more than a package on the desk.

The techniques for selling photographs and acquiring shooting assignments at an interview could fill volumes. Generally, editors look for two things in photographers: 1) Can this person take the kind of photo I need? 2) Can I work with this photographer efficiently and effectively? No amount of hustle, psychology, or glitter will get work from an editor unless you've got the right stuff in your pictures and in your attitude.

A successful interview doesn't necessarily result in instant sales. In the photography business, doors are meant to be knocked on again and again. Come back with new work, fresh ideas, and fireproof persistence.

Shooting Tips

If you're aiming to break into the magazine market, have some specific ones in mind when you go out shooting. You'll need to have the basic photo market research data about the publications. Go adventuring as if on an assignment. What you come back with will tell you whether you have pictures to show or if you need to try again.

Try and shoot diversely, as many publication photographers do. Shoot color slides and black-and-white. Even if your target publication is all color or all black-and-white, you stand a better chance of selling your photos to others when you shoot both. And for the same reasons of salability, shoot both horizontals and verticals when possible.

The classic photojournalist's approach is to shoot an overall, a medium shot, and a close-up. Let's say you're photographing an apple orchard festival. Find a vantage point where you can picture the lay of the land—the hills, trees, and crowds. A medium shot might focus on a family plucking apples off a tree. And you can guess what the close-up will be—an apple!

Textbooks

Educational publishing is a field of opportunity for photographers. It consumes photographs in great quantities and in every subject area imaginable. Many beginning freelancers get their first big break with textbooks, and many established photographers count text stock sales in their income mix.

Travel Applications

The most common languages taught in the United States are Spanish, German, French, Italian, Russian, and Latin. All language texts are photo-illustrated to give the student a feeling for the culture and to depict visually vocabulary scenarios.

Picture needs run parallel with the basic vocabularies: train station, barber shop, restaurant, newsstand, etc. Look for scenes of everyday life. Take portraits of ordinary people doing what they usually do. Take pictures of signs in surroundings which reinforce their meaning (for example, "Kino" over a movie marquee and ticket window).

Science books also use pictures from around the world. Landscapes are purchased for geography and earth science books. Cultural photos of the old and new are needed for civilization and social studies books. Plants, animals, minerals, natural phenomenon, and scientific principles in action can be used in biology, geology, chemistry, physics, and general science books.

Science texts on all levels use photos of natural phenomenon. To get an idea of what is being published, read an earth science book before your next trip. ►

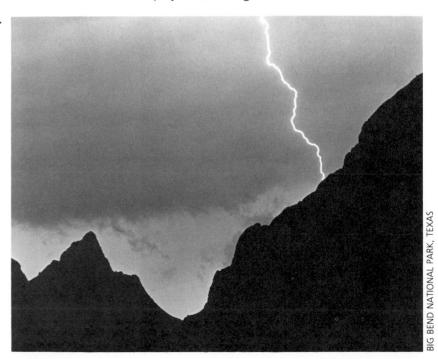

BIG BEND NATIONAL PARK, TEXAS

Breaking In

Local textbook companies are listed in the Yellow Pages under "Publishers, Book." It's always a good idea to browse through a company's texts at the public library, or even at the publisher's library before getting your portfolio together. You must know what kinds of pictures are being used in the business.

When your carefully tailored educational publishing portfolio is ready, call for an appointment. The people to see are in the art or photo-research department. If your work is suitable, you will be directed to future projects. Whether or not you hear from the publisher, return every six months with new work. And if you are planning a trip somewhere—be sure and let them know.

Shooting Tips

Like magazines, textbooks use 35mm color slides and black-and-white prints. Shoot both if you can. Kodachrome 25 or Kodachrome 64 is the preferred slide film because of its reproduction quality.

A documentary style approach is best for textbooks. The simpler and more straightforward your picture is, the better. Children are not as visually sophisticated as you are, and may be confused by strange angles, lens dis-

tortion, special effects, or heavy symbolism.

When you happen on an especially good photo situation, photograph it to the limit. Move around and explore all angles. Use a variety of lenses, get up close, put on a creative push. Having an abundance of strong photos, even if they're from only a few sources, can pay off.

◀ Photo trips to Spanish-speaking countries can pay off because it is a popular language to study in the United States. Language books use photos to illustrate everyday scenes, as well as popular landmarks.

COLOMBIA, SOUTH AMERICA

Stock Picture
Agencies

A stock picture agency is the sales representative for your past work. The agency files photographers' color slides and black-and-white prints. Then, in response to client requests, the photos are sent out for consideration.

When you submit photographs to the picture agency you are not assured of receiving any payment. First a sale must be made to one of the agency's clients. When the reproduction fee is paid, the agency splits it with the photographer (usually fifty-fifty).

The photographs themselves remain the property of the photographer. The stock agency is merely borrowing them in hopes of making sales. The actual sale is usually for one-time rights. This means that the photograph is returned after publication and can be resold.

Most professional photographers see stock picture sales as peripheral income. They have a main line of shooting work for the bulk of their earnings. After assignment photos have served their immediate purpose, salable ones are given to the agency. The photographer's personal travel pictures and experimental work are also reviewed by the agency.

Nonprofessional photographers who take their work seriously can also sell through a stock picture agency. If you take good pictures on a regular basis and they're of the kind an agency can sell, they don't care what you do for a living. For you, it's a good feeling knowing that the photos you're taking now may someday be used.

Developing a stock picture income is a slow process. Expect a return averaging $1.00 per filed image per year. You must build over the years by consistent shooting and contributing to your agency's files.

Travel Applications

Anywhere you travel has sales potential. If you have a good eye for picture-taking, a lot of film, and some luck, you can sell through a stock picture agency. The odds become more favorable if you travel to places that enhance sales potential, have some knowledge of what sells and what doesn't, and are plugged into the right agency. Then, it's just a question of time before your pictures pay for the trip.

Stock agencies differ in what type of client they serve. Image Bank, a New York agency, sells chiefly to travel magazines and advertising agencies. Stock, Boston finds its market mostly in educational publishing. Other agencies specialize in news, picture stories, or photo decor. It's crucial to know what your agency sells.

Breaking In

It is advantageous to do business with a stock picture agency in your own neck of the woods. Personal contact and professional feedback are invaluable, especially if you're just starting

out. Locate agencies in nearby cities in the Yellow Pages under "Photographs, Stock." Other listings of stock picture agencies are found in *Photographer's Market, Picture Sources,* and the Yellow Pages for Manhattan, NY.

Call for interview information. You need to know what kinds of photographs the agency sells, how many images they like to see in a portfolio, and what the interview procedures are. Some agencies have printed photographer's information sheets.

When you think you're ready, make an appointment. Don't be afraid to ask for a market evaluation of your work. Ask to see some published results of the agency's sales. Find out how the small and the large contributors are doing.

When you're accepted by a stock agency, it's not time to sit back and wait for the checks to roll in. Keep shooting and submitting new work. Ask for guidance. If you were not accepted, reapply after more shooting. After having asked the right questions during the interview, you'll know what needs to be done.

Shooting Tips

Don't second guess what your agency can or can't sell. Let them see everything.

Before traveling on vacation or assignment, ask your agency if they need anything special from where you're going.

Shoot a lot, and shoot what interests you. Bored photographers produce boring pictures.

Submit new work every six months. Color should be in the form of slides, black-and-white as quality 8 × 10 inch prints.

◀ Stock, Boston, a stock picture agency, has sold this photo for me over a dozen times. The secret to selling stock photos is making clear, direct images and knowing which subjects are in demand.

NEW YORK, NEW YORK

Photo Decor

The general acceptance of photography as "art" has opened up new markets. One such market is the photographic decoration of public and private buildings. Whether they are framed or mural-size, photographs are commanding a heftier share of the decor market every year. And in some states, specific percentages of construction costs must be spent on artwork.

On its simplest level, photo decor is selling your photographs to people who will hang them in their homes. Some photographers take their work to craft fairs and art festivals. Others display their framed pictures in restaurants, theater lobbies, and bookstores.

Galleries are another means to selling your work to the public. Dramatic, local scenes are likely sellers in a gallery. The usual gallery commission is 50 to 60 percent of the selling price.

Although it's more fun to personally hawk your photos, high volume and potentially larger profits can be made in the corporate sector. Artwork consulting companies specialize in proposing and supplying quantities of decor to office buildings. Much like a stock agency, they file your images for client presentations and pay when a sale is made. Again, a 50 percent commission is usually involved.

Public transportation, recreational sites, and buildings are often funded for artwork decoration. The funds are frequently administered through non-profit arts groups, artists' collectives, and state or federal councils on the arts.

Unlikely as it may seem, antique shops may be outlets for photography. Artwork consultant companies buy extensively from antique dealers for restaurant decor. Your current work may prove useful to this market if printed with brown toner. If you can get your hands on any old glass negatives, prints made from them can also be marketed through antique shops.

A corner of the photo ▶ decor market is occupied by old photographs. Look for outdoor, recreational, and street scenes. If you can find such a negative or glass plate in good condition, it can be marketed as wall art, postcards, or a nostalgic calendar. (Photo from the collection of Nancy Dudley)

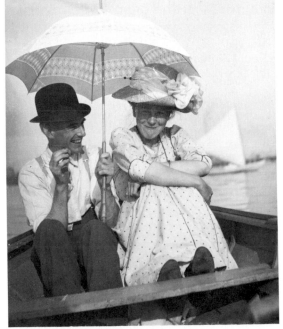

BEVERLY, MASSACHUSETTS

Travel Applications

General, symbolic images sell better as photo decor than specific images do. A flower, for example, can sell over and over. A person's face, unless it is very striking, has limited appeal to the larger audience.

Local scenes are likely candidates for banks, restaurants, executive offices, and medical reception areas. An Italian restaurant might be interested in scenes you took while traveling in Italy. A café might have your fruit and vegetable close-ups made into murals. Use your imagination!

Breaking In

Select a dozen of your best color and/or black-and-white images from your work. Have quality 8 × 10 or 11 × 14 inch prints made. Have your prints matted and put them in a box. This is your portfolio to show and sell as you knock on doors.

It's wise to have your prices already calculated. There is no real standard for pricing—but a professional looking presentation will make selling easier and the prices higher. The following can serve as a pricing guide for matted, unframed color or black-and-white photographs:

8 × 10 inches	$75
11 × 14 inches	$100
16 × 20 inches	$150
20 × 24 inches	$250
30 × 40 inches	$350
40 × 60 inches	$550

Locate artwork consulting companies and galleries in the Yellow Pages under the "Art" and "Artist" listings. Set up an appointment and show your photo decor portfolio in the way you would approach any other client. Bring along twenty good slides to show in addition to your matted prints.

The same portfolio can be shown to individuals, small businesses, and corporations. The key to selling your own photo decor is talking to people, knocking on doors, and adding new images. I suggest reading *Photo Decor* (Publication 0–22, from Eastman Kodak Company, Department 454, 343 State Street, Rochester, NY 14650: costs $8.95 plus $1.00 handling).

Shooting Tips

A medium-format camera is a useful tool for photo decor photography. The 2¼ square or 2¼ × 2¾ image size has quality advantages over the 35mm format. Grain is less apparent, sharpness is better, colors seem richer, and larger blow-ups are possible with a medium format.

Another way to achieve quality in the final print is to use the finest quality film available. This frequently means using a slow (low ASA/ISO number) film speed. The slower the film, the finer the grain and apparent sharpness in the print.

Tripods are functional equipment for any type of photography that requires exceptional sharpness. Acceptable sharpness can be obtained by hand holding your camera at shutter speeds faster than 1/60 sec., but the large prints often required in the photo decor business will accentuate any slight camera movement. Be doubly sure to use a tripod with 2¼ × 2¼ cameras, which are difficult to hold steady.

Ulrike Welsch travels and photographs for a living. Her most treasured images are not of exotic places, but of people. This is Ray Phillips of Manana Island, Maine. (Photo by Ulrike Welsch, courtesy of Globe-Pequot Press)

124

MANANA ISLAND, MAINE

Two Traveling Photographers

◄ Cary Wolinsky travels much of the year for *National Geographic* magazine. One of the things that keeps him going is the people he meets around the world, like this Irish tinker. For Cary, travel photography is a window into other people's lives. (Photo by Cary Wolinsky)

DUBLIN, IRELAND

Ulrike Welsch

Ulrike Welsch came to the United States from Germany in 1964. She was the first woman photographer on the staff of the *Boston Herald* and spent nine years as a news photographer for the *Boston Globe*. Her work has appeared in *Life, Time,* and many other publications. Ulrike has photographed the great, the powerful, and the tragic. Her photographic tour de force is telling the human story with pictures of everyday people.

The World I Love to See (Chester, CT: The Globe Pequot Press, Inc., 1981) is a showcase of Ulrike Welsch's once-in-a-lifetime photographs. Most were taken in New England on assignment and for pleasure. Some of them are reproduced on the following pages.

Since leaving the *Globe,* Ulrike is out traveling and photographing. "I have been making direct message photographs for newspapers. Now I want to take pictures with more depth." Her current project, "Rituals of the Andes," will take Ulrike into the hinterlands of South America. She has journeyed there nine times in the last ten years. I am certain we'll see the results of her travel photography in national publications for a long time to come.

Pictures That Speak

I try to make photographs which are easily understood by others. If an image can't communicate its message, it is wasted.

Always be on the lookout for details that will make your pictures speak. A cityscape can be improved if you include rooftops and chimneys in the foreground. I liven up my landscapes with good visual laundry—lots of lace and long johns!

To me, light is the most important ingredient in photography. When it's right, it makes me pick up my camera. I like to shoot from dark areas into light ones or try to put the light behind the subject. These techniques open up the scene visually and add drama. Even in the harshest midday sun, I'll find an angle to shoot into the light. When traveling, one learns to live with light and adjust the camera as situations change.

Remember that you don't have to go off to Alaska or South America for good pictures. Enjoyable photography is everywhere: driving down the road—even in your own neighborhood.

Ulrike Welsch in Callejon de Huyalas, Peru. ▶

CALLEJON DE HUYALAS, PERU

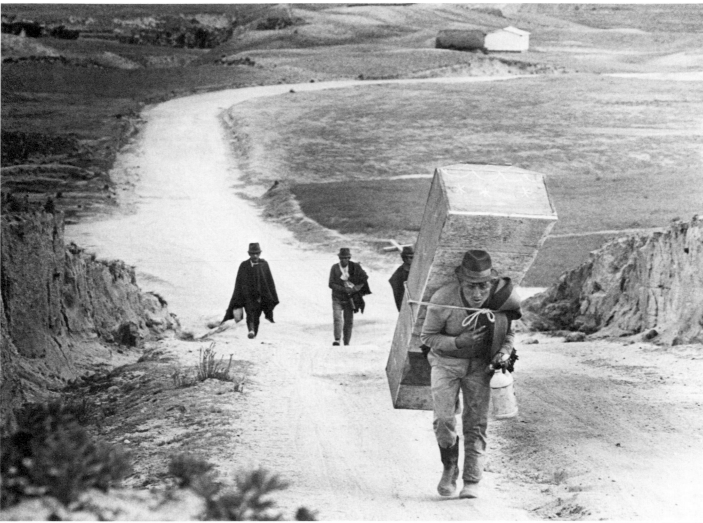

ZUMBAHUA, EQUADOR

▲
Rituals of life and death
in the Andes are a
theme in Ulrike's travel
pictures. This man
bears the casket he has
bought for his wife.
(Photo by Ulrike Welsch)

EAST BOSTON, MASSACHUSETTS

▲
"While hunting for pic-
tures in the rain, I
caught something
strange hanging on a
clothesline." (Photo by
Ulrike Welsch, courtesy
of Globe-Pequot Press)

Pictures on Foot

In the city or in an interesting village, it's bet-
ter to park the car and walk. Many good
photos are gone before you can pull off the
road. Walking along, you can tell a lot about
a people by noticing what they have in their
windows: cats, dolls, flowers, or statues.

One walk in Bangkok, Thailand, really paid
off for me in pictures. At the crack of dawn I
hiked up the staircase of a Wat (temple). The
Wat was glowing orange and gorgeous.
Later, I framed a picture of squatters' shacks
and flower gardens reflected in a tiny river.
Some casket makers invited me to photograph
their work, and then turbanned construction
workers paused to pose for my camera. I en-
countered a puppet show, a martial arts class,
and a boy with a blue rooster. I felt like Alice
in Wonderland!

Good photos can usually be taken along
rivers and canals. I like to shoot near water.
City animal markets are also interesting loca-
tions. Walk a little outside the market area
and shoot people leading their animals in and
out of the market.

Automobile Photo Techniques

When I'm driving an automobile and looking
for pictures, some things are gone by the time
I can stop the car. Other roadside scenes are
more lasting, and are more easily photo-
graphed. The driving photographer is making
decisions all the time.

As you glance out the window, notice little
things with picture potential. A woodcarver's
sign may have an interesting face behind it.
A covered bridge in Vermont would make a
great photograph if an old car or horse rode
over it. Wait, find different angles, and
maybe something wonderful will happen to
your covered bridge.

Rather than drive about aimlessly, give

WOLFBORO, NEW HAMPSHIRE

yourself a photographic destination. Regional magazines and local newspapers will tell you when and where photo events will be happening. Pick out an interesting event as your destination for the trip. Once there, comb the terrain for additional pictures. Maybe you'll see something on the way out or on the way back. Think of it as a fox hunt.

A not-so-obvious advantage of automobile shooting is the fact that many farm animals will accept a car with the motor running. An opening door and emerging photographer is more likely to frighten off an animal.

Weather photos are difficult to get. I'll park my car in a convenient shooting spot and photograph out the windows. Then I'll put on my L.L. Bean rain poncho, grab my Nikonos underwater camera, and dive into the elements.

BOSTON, MASSACHUSETTS

▲ Ulrike Welsch prefers to shoot into the light because it adds drama and depth to a scene. In this picture, backlighting highlighted the smoke and silhouetted the person in the coach. (Photo by Ulrike Welsch, courtesy of *Boston Globe*)

◄ Lunch time at the fast food restaurant, the way Ulrike Welsch sees it. (Photo by Ulrike Welsch, courtesy of *Boston Globe*)

Travel Equipment

I usually try to travel light equipment-wise, but
then I always worry about missing a picture or
a camera breakdown. On a short trip I'll carry
two Nikons, two Leicas, and eight lenses every-
where I go. True, it's a lot of equipment, but
you can always get a back rub when you get
home.

 Big aluminum equipment cases invite theft.
Some professional photographers use them,
but they limit mobility and sometimes require
helpers. The best camera bags don't look like
camera bags. My bag is a plain-looking can-
vas one with a wide strap. Most importantly,
a camera bag must be comfortable. Spray the
canvas with Scotch-Guard so it will repel
water.

 One lens that I carry, but feel is often mis-
used, is a telephoto. It will produce a good
picture when the subject is responding to the
photographer, or when two distant subjects
are involved with each other. A person just
standing there has no input—the "umph" is
missing. Interact with your subject and you'll
go home so much richer. Otherwise, you've
merely done a study for the biology books.

 My favorite suitcase doubles as a backpack.
I can walk into a fancy hotel with the suitcase
and look perfectly respectable. Later, I can
strap it on my back for greater mobility or
long treks to the train station. Lack of mobil-
ity while searching for a hotel can lead you to
settle too soon—and later regret it.

CUENCA, EQUADOR

▲
" 'Oh my God! I have to get that picture,' I said as I walked by the door-way. But the Equador-ian flour ladies weren't easily photographed. They didn't look friendly and I felt shy. So I talked with some chil-dren and some cus-tomers inside the store to warm myself up. Soon I was chatting with the flour ladies and we eventually took pic-tures." (Photo by Ulrike Welsch)

BERMUDA

◄ The Norwegian Tall Ship "Christian Raddich" furling its sails. (Photo by Ulrike Welsch, courtesy of Globe-Pequot Press)

Companions

Sometimes you have to go off on your own. work better alone and I also get concerned about making a companion wait while I'm shooting. You can be out for sunrise pictures and meet your friends later at a prearranged place.

An accompanying entourage can be a hindrance. People feel easier about being approached by one person, and it's easier to make friends when you're alone, At a refugee camp in Thailand, I was constantly being introduced by our translators. All the natural moments I saw were spoiled. And it's extremely difficult to set something back up in a foreign language. I finally said I'd meet them outside the camp on the Mekong Road.

Techniques for a World Traveler

A friend of mine is preparing to travel around the world. I envy him. He just bought some cameras and all he needs to do is firm up on photography. Here is my advice on some techniques.

- Make use of the equipment you've got. Just changing your camera angle can result in different impacts and messages.

- Simple photographs are the most effective. Use a wide lens opening to eliminate distracting backgrounds.

- Don't force it. If you're visually tired, don't photograph every day.

- Stay in one spot for a while. Find a place you like, become familiar with it, and then branch out.

- Always keep film in your camera. If it's empty for some reason, lift the rewind knob as a reminder.

Looking at People

I choose my subjects carefully. They're not all beauty queens, but they have a smile, a pipe, a floppy hat, or some special quality. They have character. Normal looking people may be fun, but I'll take the unusual face.

I have to feel right before I can go right up and photograph people. Someone with a wonderful face will get me started. Then I'll say "hello" and get into conversation. By talking I can tell if they'll let me photograph them and at the same time weigh how much effort I'll put into getting the picture.

I relate to my subjects better at times by mentioning a local person or the place where I'm staying. It inspires more trust than someone who is just passing through. And being a woman alone a lot of the time, having local references decreases my psychological, if not physical, vulnerability.

It's important for the traveler to learn a few phrases of a foreign language:

- Hello.

- May I take your picture please.

- You are very pretty!

- Thank you.

Also try saying:

- Please go on as you were doing.

- I like when people work with their hands.

For the Fun of It

I take hobby pictures all the time, and I still like it. Photographing an interesting person gives me joy. The satisfaction is there, whether it's for work or for play.

Part of the joy I get from photography is sharing pictures I like. A show covering a long period of shooting reveals more to my viewers: quality that is not possible in publications. The show as an entity gives a lasting impression. It helps my ego, and I like to stay in the public eye.

◀ Harold Hildretch, a man whose interesting face brought Ulrike back to photograph him many times. (Photo by Ulrike Welsch, courtesy of Globe-Pequot Press)

SHERBORN, MASSACHUSETTS

CAPE COD, MASSACHUSETTS

▲
If you have a fantasy
that is unlikely to hap-
pen on its own, try to
arrange it naturally. Be
a movie director. Make
your subjects work and
they'll forget about you.
(Photo by Ulrike Welsch,
courtesy of *Boston
Globe*)

Cary Wolinsky

Cary Wolinsky is a contract photographer for *National Geographic* magazine. He has covered England, Northern Ireland, Pennsylvania, Australia, and the U.S. Virgin Islands. His latest assignment has literally taken him around the globe. Here is a distillation of conversations with Cary Wolinsky, in which he shares some of his insight on travel photography.

Why Travel?

Travel is a key to meeting people. *National Geographic* opens doors, but just the camera can be the way into someone's life. It breaks the ice and suddenly you're talking to someone about their way of life. You come home knowing a whole lot more about the world than if you'd just seen some cement and stone.

It's fun diving into other cultures and photographing what makes them colorful. You can see how history, climate, and terrain have molded a people. They are a window into a thousand years of history.

On location in the U.S. ▶ Virgin Islands for *National Geographic* magazine, Cary Wolinsky focuses on two horses riding down the beach. Much research and planning go into Cary's photographs.

ST. THOMAS, U.S. VIRGIN ISLANDS

Researching a Trip

Before going on a trip, go to the library. Read encyclopedias and books for historical background, and magazines for more recent information. For the *Northern Ireland* story, I read Jill and Leon Uris's *A Place Apart,* a book on bicycling through Northern Ireland, *Ireland's Civil War,* and the tour book *Discover Northern Ireland.*

When you arrive, go to a good bookstore and browse through relevant books. Local bookstores have more material about the place you're in than anywhere else in the world. Buy the most helpful books. Also get the *Yellow Pages.* The phone book has leads on interesting businesses, restaurants, and gives you a sense of proportion about the place. In addition to steering you toward better picture opportunities, the knowledge you gain from research can help you get along with other peoples. If you know a little about their history, their culture, who their George Washington is, they'll respond to you better.

Notes

A good rule about note taking: when in doubt about if you'll ever use some information, write it down. Take notes on all your initial research at home. On the airplane, always ask the person seated next to you "Are you going home?" I badgered thirty hours of notes from some poor guy on the way to Australia. When on a story, make a general outline of things you think you want to photograph: culture, education, industry, etc. Then start filling in the general topics with names and phone numbers of specific subjects. Your notes become more detailed as you take shots and meet subjects. Keep your notes in a small hardcover notebook. Years later you'll be able to retrieve details about a picture or an address.

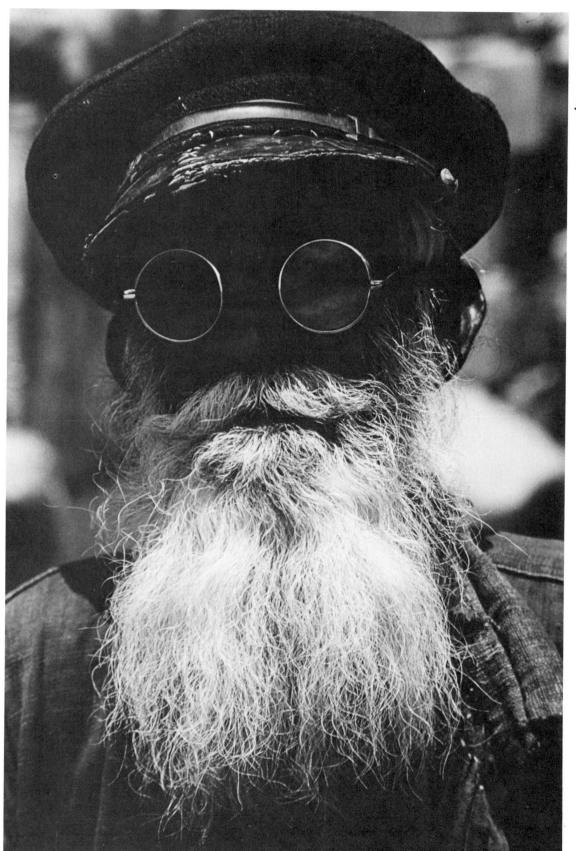

◀ Unusual faces some-
times come and go
quickly. Cary photo-
graphed this gentleman
on a train platform in
India. The man
thanked him and then
disappeared. It is one
of Cary's favorite pic-
tures. (Photo by Cary
Wolinsky)

RAJASTAN, INDIA

Film Return

The safest way to get your exposed film home is to carry it back yourself. But if you need to send batches of film back, be careful: use air freight through an international courier service. Your time and effort in getting all those pictures is worth a first-class ticket home for them.

In certain Third World countries, using the postal service is risky. There is some likelihood that the stamps on your package (and the package itself) will be stolen by a postal worker. Five dollars in stamps may be someone's salary for the week. If you absolutely must use the mails, bring your package to the post office and have the stamps cancelled in front of you.

Surviving the Airport

One of the great neglected photo subjects is the airport, and so many photographers spend so much time there. The fact that modern airports are designed to make travelers as uncomfortable as possible makes for humorous pictures. Men in business suits are curled up asleep on coffee tables. Rows of people are glued to pay televisions attached to their seats.

Airports are terribly emotional places. Go to any arrival gate and you'll see kissing, weeping, and hugging. You'll see anger at ticket counters and bewilderment as suitcases spill their contents onto the pavement. There's enough material at airports for a book!

Customs Tips

- Carry a typed inventory of all your equipment and several photocopies of it. Much time can be saved by presenting this list or transferring it to an official form.

- Don't carry dutiable items, like liquor or cigarettes. Doing so is asking to have your bags inspected.

- Check ahead to see if you're carrying in more film and equipment than a country will allow. Special clearances and documents should be in hand well before departure.

- Register your equipment with your own country's customs before leaving.

- Be nice to customs people, no matter how rude they are.

Luggage

Carry onto the aircraft all the photographic equipment you can. Packing it in your luggage is risky. If you mark your bags FRAGILE, some airlines require you to sign a waiver releasing them from the responsibilities of damage. It's better to pack your stuff as if it were nitroglycerine and keep your fingers crossed.

It's easy to forget what's missing in a crowded airport. When carrying more than four suitcases, put big numbers on the side of each bag with tape. If you've described each bag and its contents in your notebook, you can help the airline identify it and also determine what impact its loss will have on your trip.

One handy item to have along is gaffer's tape. To this traveler, it's almost more important than film. Tape all suitcase latches and zippers to keep out moisture and prevent accidental opening. If a bag or camera breaks, gaffer's tape will hold it together. You can even improvise a suitcase handle with a stick and tape.

BENARES, INDIA

◀ ''As I walked down the stairs in the Benares, India, train terminal, a cow came walking up. Only because I had a camera free of the bags did I get this picture. You never know what's going to happen next on a trip, so always have your camera ready.'' (Photo by Cary Wolinsky)

Picture Planning

I meet tourists all the time who are serious about getting good pictures. And that's the purpose of their travel: to have fun and shoot pictures. A dilemma many of these people face is feeling obligated to photograph certain monuments. They're not, and there are fascinating alternatives.

Personal Interests: First of all, don't be afraid to pursue the things that interest you as a human being. Pursue your curiosity. That's what makes for style in a photograph. In London, for example, they say you've just got to visit Big Ben. Personally, I'm more interested in the English people and their character. So go to the pubs—that's where England is!

Factory Tours: More and more travelers are realizing that major industries offer free tours. It can add a whole new aspect to your vacation to get a sense of what people really do there. One of the best tours I had was at the Mount Tom Price iron mine in Australia, the largest in the world. Every hour a bus takes people out and they'll stop anywhere you want for pictures.

Finding Surprises: I spend a lot of time on the road researching and looking for little surprises. The local paper is a valuable source. It not only has the weather and sunrise/sunset times, but also news and special events. Without a paper, you could miss a festival only two blocks from your hotel.

The photographer's choice of the time of day can be just as important as the shooting location. Cary Wolinsky favored sunset on the Ganges for this photograph. (Photo by Cary Wolinsky)

▼

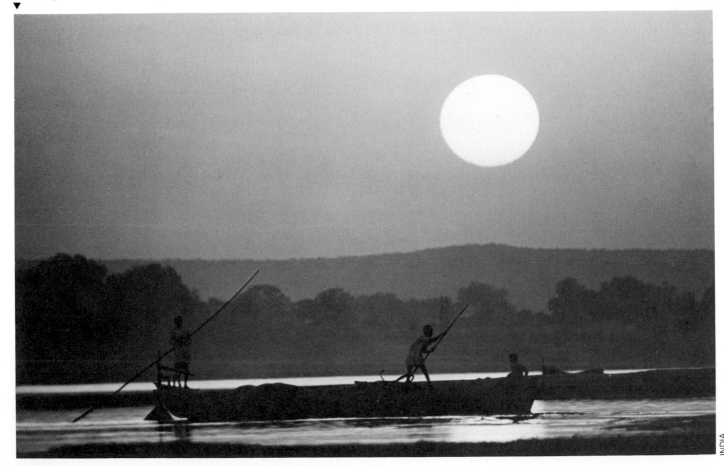

INDIA

Weather: No one except the weatherman is more keenly aware of the weather than I am. I'm always trying to anticipate my shooting schedule based on the newspaper, airport, and television forecasts. If you know it's going to be an unusually cool night, you can be ready to shoot mist rising off the water ten minutes after the sun hits it. Great travel pictures that are gifts are pretty rare. You have to plan ahead and sometimes help it happen.

Time of Day: Most photographers favor early morning and evening light, and for two reasons: the colors are especially good, and there is a unique pace during first light. So if you wander about almost anywhere early in the morning, the chances of getting good pictures are favorable.

At dawn, or in predawn light, there are magical black shapes against pastel colors. Sometimes it's worthwhile to view a spot in more than one kind of light, because time of day can make it boring or spectacular.

People are outdoors more in warm countries. In India, even at dawn, you'll see people sleeping on the street, bathing, and perhaps the navy out on a sunrise run. For the nonprofessional who doesn't have time to constantly arrange picture sessions, warm countries offer more.

Always keep an eye ▸ peeled for detail; it was not by chance that the bottom left boat is named ''Peace.''
(Photo by Cary Wolinsky)

KILKEEL, NORTHERN IRELAND

Street Shooting

Some photographers think the whole world is one big Disneyland. You shouldn't expect people to pose for you every time you lift up your camera. It's a privilege to photograph someone, and sometimes it must be earned.

When you're after candids, put the camera up to your eye and see how people react. If they duck or hold the menu over their face, it means "don't photograph me." Their wish should be respected.

Down on the dock in Charlotte Amalie, in the U.S. Virgin Islands, old men sit and play dominoes. It's a really nice, colorful scene. Before I even got close, they started yelling "No pictures—Go away!" They were tired of tourists poking lenses at them. I wanted the

picture badly so I sat with them for a couple of hours. We got to know each other. Then one of the old men said, "Why don't you take our picture? Nobody ever takes our picture. Send us some prints!" Be human, smile, and maybe you'll get the picture.

Carry a wide-angle lens for candid shots. It covers more area than people realize. Put a 24mm lens on your camera and see how far away from your subject you can point the camera and still have the subject be a major part of the frame. Often this works well in a complex scene, like a marketplace, where the edges can hold the important part of the image. With careful composition, you can have relaxed and unaware subjects in your picture, and they all think you're zooming in on a banana.

A telephoto lens is also good for fast street shooting. I use the fastest lenses I can get because light changes from one moment to the next. One minute it's bright sunlight and the next you're shooting in a dark doorway. I also carry a short telephoto—an 85mm.

No matter which lens you use, know how far from your subject to stand to get the right amount of coverage. I can tell now without looking through the camera. Practice and practice, like it's a musical instrument.

Some photographers overcome camera-to-subject distance with zooms. I meet professionals all the time who carry one camera and a zoom lens. Personally, I like to know exactly what focal-length lens I'm grabbing from my camera bag, so I can be standing in the right place. Good photographs happen fast.

Photographers have many trepidations about street photography. The kind pictured here is the most hazardous. Although Cary doesn't always get the candid photo he's after, he knows it's worthwhile to try. (Photo by Cary Wolinsky)

NORTHERN IRELAND

OMAGH, NORTHERN IRELAND

◄It takes a photo diplo-
mat to get people to
act naturally in the pres-
ence of a camera. A
good way of saying
"thank you" is to send
your subjects a print for
their time and effort.
(Photo by Cary Wolinsky)

Photo Diplomacy

As a traveler, you're an ambassador for what-
ever country you're from, and you're an am-
bassador for yourself. And when you work
for a magazine like the *National Geographic,*
it's even more critical: writers, caption writers,
and researchers still have to deal with your ini-
tial contacts. It never pays to leave a rocky
wake.

I feel strongly about sending photo presents
to everyone that I possibly can. Even if you've
just asked someone to move their head a lit-
tle, send a gift. They've done you a favor.
And you don't realize how appreciated and
personal your gift can be.

From the practical side, if you promise a
picture and don't send it, that person won't
be happy about you or the next photographer
coming through. A print sent to someone
who really isn't expecting it is like manna from
heaven. What does it cost—35 cents? Giv-
ing away instant pictures on the spot is a
great idea, too.

People are interested in strangers. When
you travel, you're a little piece of your country
that's come to visit. In remote villages, that's

the closest some people are ever going to get
to your country. No matter where you're
from, you can see how important your diplo-
macy is. So don't be surprised when some-
one asks if you know J.R. Ewing!

Your friends at home shouldn't be forgot-
ten. Before I leave, I type a list of names and
addresses of friends I want to keep in touch
with. The list is formatted so that it can be
photocopied onto peel-off mailing labels.
Whenever you've got spare time on the trip,
you can peel off some labels and write post-
cards. Even the simplest note is appreciated.

Some countries are business card crazy.
Pack lots of them for all the people you'll
meet while traveling. They'll appreciate it and
it saves you from writing your name down
four hundred times.

Favorite Lodging

I prefer not staying in hotels. Hotels are expensive, uncomfortable, and restrictive. When I'll be staying in one place for more than a week, I'll rent an apartment or a house. The cost is about one third the price of a hotel room and you can cook your own meals. This is important to me because if I'm out shooting before sunrise I can fix myself breakfast.

Renting your own place also gives you the comforts of a home and more time to yourself. You don't have to deal with the hustle and bustle of a busy hotel. Almost everywhere I've been has an agency that rents these accommodations. And before you leave, request travel information on "self-catering accommodations."

When he touches down ▶ in a new environment, Cary Wolinsky takes advantage of a heightened cultural awareness. People, land forms, and even animals gradually lose their novelty as the travel photographer becomes accustomed to the surroundings. (Photo by Cary Wolinsky)

ROTTNEST ISLAND, AUSTRALIA

Cultural Awareness and Culture Shock

The first few days that you're in a new place, you notice what's unique about it. Maybe it's the signs, the native dress, or the sidewalk cafes. Little things strike you as interesting. The best time to photograph cultural details is during the first few days. Then they disappear as part of the overall scene.

I can give you a hundred tips on traveling, but the most important thing is not to be afraid. Be as prepared as you can, be cautious—but don't be afraid. You can work yourself into a panic situation and scare yourself out of a country. I've seen tourists come into India and leave the same afternoon.

When you enter a country that looks like it's going to be a major culture shock, treat yourself to a good hotel for the first night or two. You know there'll be a breakfast looking something like what you're used to. If you have your own little capsule where you can comfortably retreat, it's a lot easier to dive into a new culture. After adjusting and with the recommendations of people you meet, you should be able to handle a less expensive place.

If you're afraid of losing your equipment, just use some common sense. Have lockable bags, and keep them out of sight in your hotel room. Ask to not have your room cleaned and hang up the "Do Not Disturb" sign when you go out. Check your camera bag at the hotel desk if you won't be shooting.

Be sure to have a car with a lockable trunk. Never leave your cameras out on the seat if you're leaving the car. Load and unload equipment from the trunk in places where you're unobserved. Following these precautions will minimize the chances of theft.

The Traveling Photographer's References

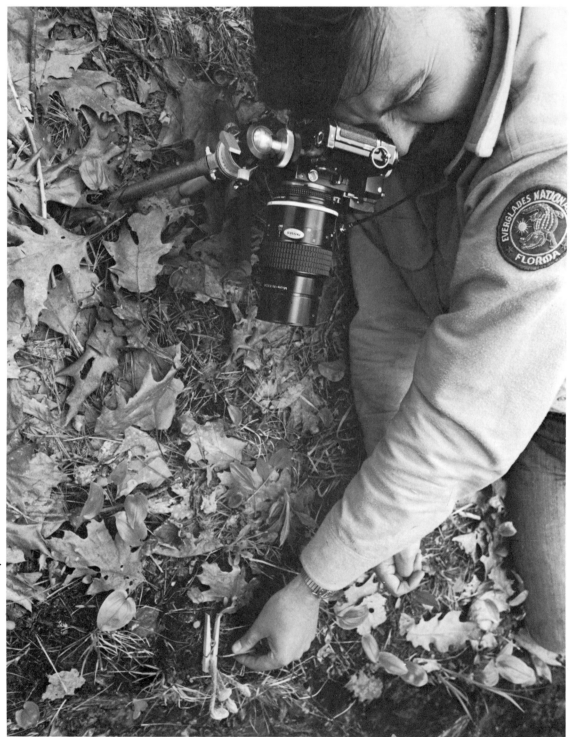

Extreme close-ups, long ▶ exposures, and varied light sources are technical challenges for the travel photographer. A good habit is to refer to additional information when unusual situations are encountered. Then your exposures will be in the ballpark and you have a much better chance of getting the picture you want. (Photo by Nancy Dudley)

WHITE MOUNTAINS, NEW HAMPSHIRE

Resources and References

Photo Accessories

Your Local Camera Store: You may find it cheaper to buy equipment by mail, but the service you get from your community photo dealer is unbeatable. A good camera store will give you fair prices, current product information, equipment instruction, and help you out when there's a malfunction. Wise camera store owners realize that it's their business to make sure you enjoy photography and shop at their store again.

Inkadinkadoo, 95 Prince Street, Jamaica Plain, MA 02130: Reasonably priced rubber stamps of all descriptions, including a postcard stamp. They will also cut a stamp to your original design. Write for information.

L.L. Bean, Inc., Freeport, ME 04033: Mail order supplier of outdoor gear, some of which comes in handy for the travel photographer. Rain ponchos, packs, mitts, weatherproof cameras, and other specialized equipment. Free catalog.

20th Century Plastics, Inc., 3628 Crenshaw Blvd., Los Angeles, CA 90016: Albums, slide sheets, negative preservers, and other plastic items to help you organize and display your pictures. Free catalog.

Light Impressions Corporation, Box 3012, Rochester, NY 14614: Quality and archival framing materials. Write for catalog.

Picture Guild, Box 331, Jamaica Plain, MA 02130: Top quality light tables, camera straps, flash brackets, and other photo accessories—designed by photographers for photographers. Write for free catalog.

Pioneer and Company, 216 Haddon Avenue, Westmont, NJ 08108: Distributors of EWA Marine flexible underwater camera housings, rain covers, and related products. Write for literature or dealer nearest you.

Porter's Camera Store, Inc., Box 628, Cedar Falls, IA 50613: A mail order store specializing in photo accessories. Many items offered are difficult to find anywhere else: photographer's patches, liquid photo emulsion, photo linen, and many discontinued items at bargain prices. Free catalog.

Ultimate Experience, P.O. Box 2118, Santa Barbara, CA 93120: Backpacks, fanny packs, and day packs designed specifically for photographic equipment. Write for catalog or the nearest dealer.

Photo Technique References

The Freelance Photographer's Handbook, by Fredrik D. Bodin (Somerville, MA: Curtin & London, Inc., 1981). A realistic analysis of today's photo marketplace and how to start selling pictures, either part-time or full-time.

Photographer's Market, edited by Connie Achabal (Cincinnati, OH: Writer's Digest Books, updated every year). A comprehensive listing of over 3,000 photo markets, their photo requirements, and prices.

Into Your Darkroom Step-by-Step, Dennis Curtin with Steve Musselman (Somerville, MA: Curtin & London, Inc., 1981). Beginner's guide to processing film and making prints in your own darkroom.

The Book of 35mm Photography, by the Editors of Curtin & London, Inc. (Somerville, MA: Curtin & London, Inc., 1983). Guide to basic 35mm single-lens-reflex photography, plus special techniques such as when to override automatic exposure, flash photography, equipment and accessories and how to use them, and more.

Traveling References

A Guide to the National Parks, by William H. Matthews III (Garden City, NY: Doubleday/Natural History Press, 1973). A comprehensive rundown on all the national parks, their landscape, geology, and unique features. Also has travel advice and photo tips for some parks.

Let's Go: USA, by the Harvard Student Agencies, Inc. (New York: St. Martin's Press Inc., updated every year). The travel guide for those on a budget. Covers lodging, food, transportation, special needs traveling, and more. Also available for Europe, France, Italy, Britain & Ireland, and Greece, Israel & Egypt.

National Geographic Magazine, by the National Geographic Society (17th and M Streets, Washington, DC 20036, monthly). The best value for armchair traveling, travel ideas, past and present cultures, and a showcase of fine travel photography.

Metric Conversion Chart

Distance

1 millimeter = .039 inch = — = —
1 centimeter = .39 inch = .03 foot = —
1 meter = 39.4 inches = 3.28 feet = —
1 kilometer = — = 3280 feet = .62 mile

ASA/ISO and DIN Conversion Chart

ASA/ISO	DIN
16	13
25	15
32	16
50	18
64	19
80	20
100	21
125	22
160	23
200	24
320	26
400	27
640	29
800	30
1250	32
1600	33
2500	35
3200	36

Weight

1 gram = .035 ounce
1 kilogram = 2.21 pounds
5 kilograms = 11.02 pounds
10 kilograms = 22.04 pounds

Time

00:00	=	12:00 Midnight	12:00	=	12:00 Noon
01:00	=	1:00 A.M.	13:00	=	1:00 P.M.
02:00	=	2:00 A.M.	14:00	=	2:00 P.M.
03:00	=	3:00 A.M.	15:00	=	3:00 P.M.
04:00	=	4:00 A.M.	16:00	=	4:00 P.M.
05:00	=	5:00 A.M.	17:00	=	5:00 P.M.
06:00	=	6:00 A.M.	18:00	=	6:00 P.M.
07:00	=	7:00 A.M.	19:00	=	7:00 P.M.
08:00	=	8:00 A.M.	20:00	=	8:00 P.M.
09:00	=	9:00 A.M.	21:00	=	9:00 P.M.
10:00	=	10:00 A.M.	22:00	=	10:00 P.M.
11:00	=	11:00 A.M.	23:00	=	11:00 P.M.

Film and Print Size Equivalents

35mm format = 24 × 36mm image area
6 × 6 cm = 2¼ × 2¼ inches
6 × 8 cm = 2¼ × 3¼ inches
7.6 × 12.5 cm = 3 × 5 inches
10 × 12.5 cm = 4 × 5 inches
12.7 × 18 cm = 5 × 7 inches
20 × 25 cm = 8 × 10 inches

Color Temperature Chart

Color film is balanced to produce accurate or standard colors when used only at certain color temperatures of light. Daylight-balanced film produces accurate colors when used in midday sunlight; the color balance of the photograph will shift if the same film is used in other types of light. You may not always want a "standard" color balance. For example, light at sunset casts a warm golden glow on a scene that is often pleasing and desirable. However, if you want a more standard balance, use the filters shown on the chart below.

Source of light	Temperature of light (degrees Kelvin)	Filters for normal color balance with daylight film	Filters for normal color balance with tungsten (3200 K) film	Filters for normal color balance with Type A (3400 K) film
Open shade	10,000 K	85C	85B + 85C	85B
Electronic flash	6,000 K	81A or none	85B	85B
Midday sunlight	5,500 K	None	85B	85
First and last two hours of sunlight	4,000 K	82A + 82C	81 + 81EF	81D
First and last hour of sunlight	3,600 K	80C + 82A	81C	81A
Photofloods	3,400 K	80B	81A	None
Quartz photo lights	3,200 K	80A	None	82A
Sunrise, sunset	3,100 K	80A + 82	82	82A
100-watt table lamp	2,900 K	80A + 82B	82B	82C
Candle	1,500 K	NR	NR	NR

NR = Not recommended

Close-up Exposure Compensation

Extreme close-ups require added exposure. Your camera's through-the-lens meter will automatically indicate the correct exposure, or you can use the 35mm Close-up Exposure Scale. Simply place the scale directly in front of the subject. Position the scale so it is parallel with the narrow side of the picture as you see it through the viewfinder.

The "O" mark must be on one side of the frame. The exposure increase will be on the opposite edge of the frame.

▲
The exposure scale was used in an upright position for this horizontal close-up. A vertical shot would require putting the scale on its side, spanning the narrowest width of the frame.

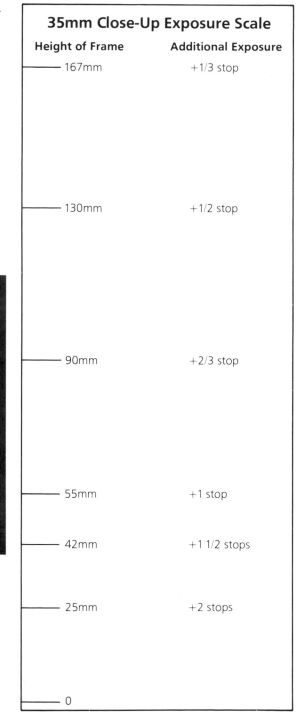

35mm Close-Up Exposure Scale

Height of Frame	Additional Exposure
167mm	+1/3 stop
130mm	+1/2 stop
90mm	+2/3 stop
55mm	+1 stop
42mm	+1 1/2 stops
25mm	+2 stops
0	

Index